IMAGES
of America

LAWRENCE
IN THE GILDED AGE

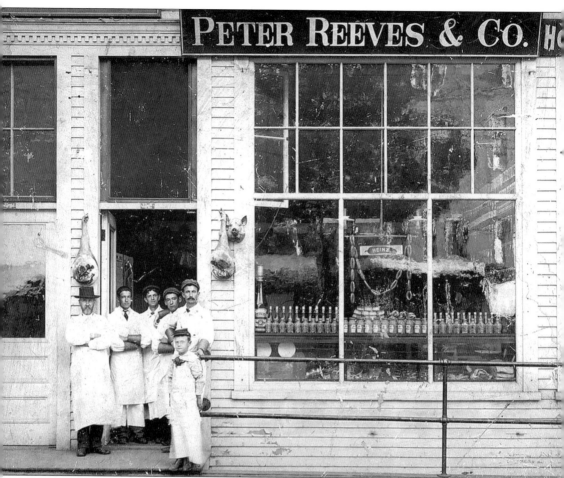

This photograph shows the workers at Peter Reeves & Company, purveyors of pork sausage and bacon. It was originally located at 113 Essex Street. The shop in this photograph was located at 274 Essex Street. (Courtesy Joe Bella.)

IMAGES
of America

LAWRENCE
IN THE GILDED AGE

Louise Brady Sandberg

ARCADIA

First published 2004

Published by Arcadia Publishing,
an imprint of Tempus Publishing Inc.
Portsmouth NH, Charleston SC, Chicago,
San Francisco

Printed in Great Britain

Library of Congress Catalog Card Number: 2003115626

For all general information, contact Arcadia Publishing:
Telephone 843-853-2070
Fax 843-853-0044
E-mail sales@arcadiapublishing.com

For customer service and orders:
Toll-free 1-888-313-2665

Visit us on the Internet at www.arcadiapublishing.com

On the cover: This photograph was likely taken at the Essex Agricultural Society Fair in
Lawrence. The two-day fair was held at different towns in Essex County every year. The
Lawrence fairgrounds were located on south Union Street. Plowing matches and other events
would take place there and at other spots around the city, and agricultural products, cattle, and
poultry would be on display in city hall. Merchants exhibited agricultural tools. One such fair
took place on September 26 and 27, 1882.

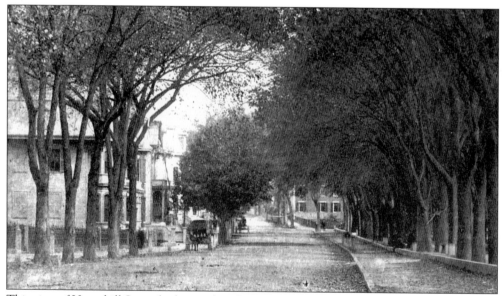

This view of Haverhill Street looks east from Lawrence Street. The main streets of the city were
lined with trees in those days.

4

CONTENTS

ACKNOWLEDGMENTS

I owe a great debt to my husband, Michael, for his many hours of editing and thoughtful comments. I also want to thank my sister, Julia Ratliff, for her suggestions for title headings. I cannot forget the help of Barbara Brown, whose continual moral support and text ideas were invaluable. Joe Bella, an avid Lawrence history collector, allowed me to use some images of everyday people in Lawrence. Pat Jasayne from the Lawrence History Center provided a few more images and looked over the manuscript for factual errors. I want to acknowledge the continued support of our library administration—Javier Corredor (director), Sharon Doyle (associate director), and Maureen Nimmo (assistant director of adult services)—for giving me the time to do this project; our reference staff—Ana Santos and Kemal Bozkurt—for their understanding and support; Fabian Rojas, Damaris Lamontagne, Ingrid Portorreal, and Elvin Fabian for their technical assistance; Maureen Murphy for answering many questions about the history of Lawrence; and Gayle Forster for her editing help. Jim Beauchesne of the Lawrence Heritage State Park looked over the manuscript for factual errors. Finally, I want to thank the brethren of the Lawrence United Masonic Lodge for working so hard to help me.

I dedicate this volume to the people of Lawrence who have made my work so enjoyable. The history of the city is a rich tapestry that I have been privileged to study. I only hope that a portion of the pleasure that I derive from the library's Queen City Room comes across in this book.

INTRODUCTION

The term "Gilded Age" comes from the title of an 1873 novel by Mark Twain and Charles Dudley Warner. The novel satirized the ostentatious display of wealth of America's newly created capitalist aristocracy. This opulent veneer was the gilded part of the age. In fact, the last three decades of the 19th century presented what seemed to be endlessly expanding opportunities (albeit intermixed regularly with recessions). The age also fostered a growing disparity between the nouveau riche and the poor.

Those heady days after the Civil War saw the fantastic rise of cities across the country, and the expansion of the railroads brought in more markets for the goods just starting to pour out of eastern factories. A need arose to build more factories and hire more workers, thus fueling the steady flow of immigrants. Two consequences of these changes were nostalgia for a simpler agrarian time and the progressive movement. The overall success of industrial capitalism led many to believe that this ever increasing wealth was the reward for those of the upper middle class. "The race is to the strong," said William Lawrence. "Godliness is in league with riches." To many, the appearance of America's triumph over poverty and cultural deficiencies was a victory of the democratic experiment. If human beings, unfettered by government, tradition, and historical restrictions, could turn the wilderness into a paradise, anyone could join the experiment and make his or her own dream a reality.

This unparalleled opulence, however, led to an opposing effort by reformers to provide benefits and services for everyone by redistributing the wealth. City fathers worked to change the landscape from small crowded streets and alleys to broad avenues lined with stately public buildings. Cities hired engineers to create modern sewer systems and sources of fresh water to counteract the escalating incidence of disease. Streetlights and paved roads were also signs of these emerging cities' desire to promote a commercial center for all. New institutions, such as public libraries and city charitable organizations, were adding positive elements to urban living. Communities began to create additional parks and playgrounds to make city living more healthful. City parks also became a meeting place for all classes. The growing middle class wanted comfortable homes, whether in the city or in the new suburbs. Smaller cities sprang up to provide specialized industry (for example, mills), bridging the gap between the cosmopolitanism of the big cities and the provincialism of the small towns.

The city of Lawrence was a microcosm of the developing American urban scene. Lawrence's population began at nearly 29,000 in 1870. By 1900, the city had grown to over 62,000. The Lawrence Board of Trade saw the burgeoning population as a sign of progress. All aspects of the

city were becoming bigger and better. There were more spindles in the mills and more employees in the tenements. The mills would continue to produce the world's fabric, and the lives of management and the middle class would continue along their separate paths toward a rosy future.

Lawrence mirrored the evolution of city life in Gilded Age America. As you will see from the images in this book, Lawrence was building grand public buildings, developing parks, welcoming new technology, establishing city institutions (such as the public school system and the library), and designing up-to-date infrastructures (a water department, roads, bridges, and so on) just as other cities in the country were doing.

As the special collections librarian at the Lawrence Public Library, I have had the good fortune to organize the library's large collection of historical materials that were the basis of an exhibit during the city's 150th anniversary year. While sorting and organizing photographs, manuscripts, printed materials, artifacts, and ephemera, I kept asking myself questions: Where were these places? Who lived here? What is here now? So many things—both buildings and institutions—had been lost to time that I chose a visual display, called "Forgotten Lawrence," describing the life and times of 1895 as the theme for the exhibit.

This book expands upon that exhibit, covering Lawrence from 1870 to 1900, during the Gilded Age. The material used in this book is mostly from the library's collection. I have attempted to open a window to the past and recapture a vibrant and exciting time. Many of the images show Lawrence as it was before living memory. Any omissions or other deficiencies are generally due to the scarcity of information and images. I welcome information from readers to continue to tell the story of the city.

One

THE MILLS

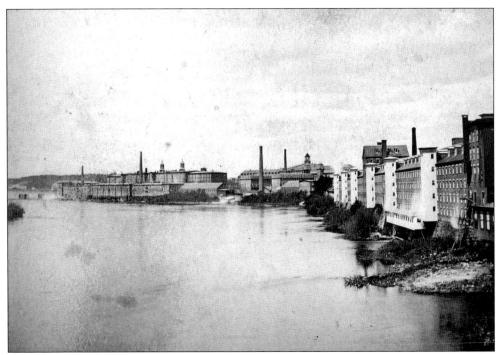

The city of Lawrence was planned to be a center of commerce, both for the manufacturing of products for profit and for housing the employees who would patronize the businesses that blossomed around the mills. The Essex Company was a Boston-based corporation that organized the funding to create this new industrial center, first called Merrimack and later Lawrence (after Abbott Lawrence). The Essex Company built the dam in 1845, and the incorporation of the town followed in 1847. This photograph is from a very early stereo slide of the mills on the Merrimack River.

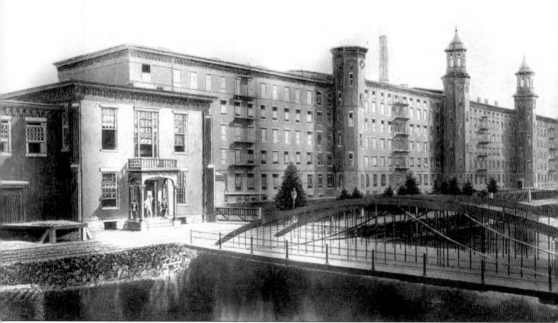

Pacific Mills was incorporated in 1853 with capital of $1 million. The original mills and print works were built by the Essex Company, remodeled in 1882, and enlarged and added to over the many years of its operation. In the latter part of the 19th century, the company was considered one of the foremost corporations in the world. Abbott Lawrence, the city's namesake, was the first president. The company started as a producer of women's dress goods in wool and cotton, and included a print house and dye works. By the 1890s, the mills were producing calicos, lawns, shirtings, and a large variety of other products. By 1895, there were over 200,000 spindles turning.

The building of the East Weave Shed of the Upper Pacific Mills started in the early spring of 1889. There was a need to produce more cloth for the print works. The shed was 329 feet long and 74 feet 4 inches wide. The basement was 10 feet high, and the other three stories were 13 feet high. There was a brick stair tower at the southeast corner, and an Otis hydraulic elevator was placed in the middle span. (Courtesy the Pacific Mills collection.)

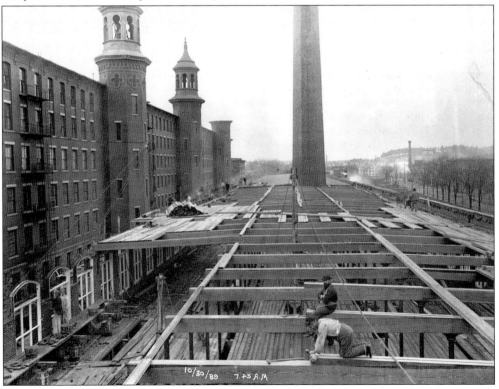

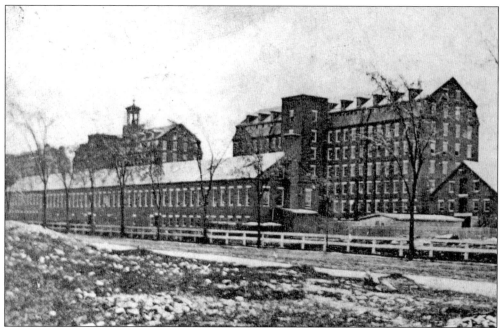

Washington Mills was organized in 1858 with property that had belonged to the Bay State Mills, the first mill operation in Lawrence. Those buildings burned and were replaced by a large six-story building on the same site. It was a wool mill of 140,000 spindles. In the early years of the 20th century, this corporation would expand into the huge Wood Mill and the associated Ayer Mill, with its famous clock tower.

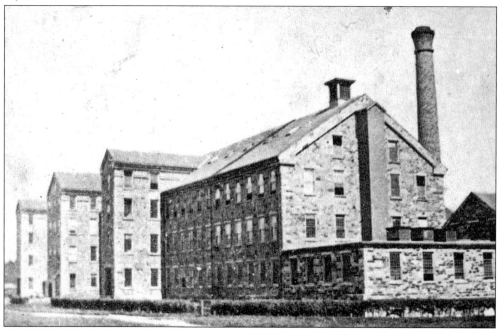

Everett Mills, incorporated in 1860, produced dress goods, gingham, and a variety of cotton products. The mills boasted 52,000 spindles in the later years of the 19th century. The buildings in the photograph were originally occupied by the Lawrence Machine Shop.

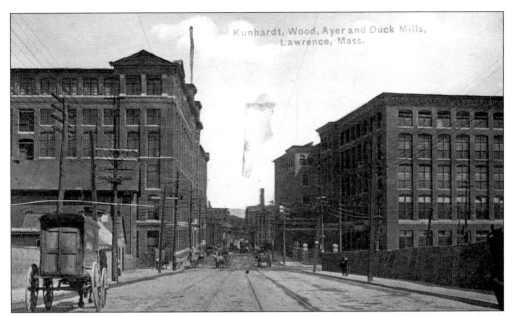

Kunhardt Mills, the building on the left, was established in 1886, when George E. Kunhardt bought the Lawrence Woolen Company (also known as Perry's Mill after the founder, Capt. O. H. Perry). The company's primary products were woolens, worsteds, and uniform cloth. The mill was located at the corner of Union and Island Streets. It is now the home of a number of businesses and the city's new institution for higher education, Cambridge College.

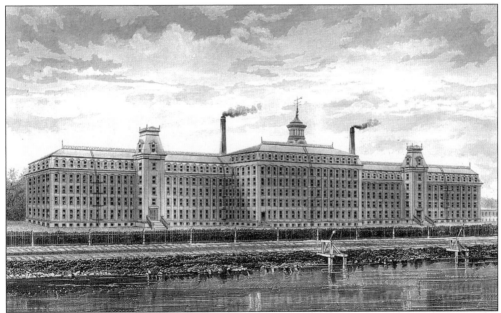

Atlantic Cotton Mills came into being in 1846. The main building was constructed in 1883. The plant was located on Canal Street between Amesbury and Hampshire Streets. The Upper Pacific Mills (cotton) flanked the Atlantic Mills on the west side and the Lower Pacific Mills (wool) on the east side. Abbott Lawrence was the first president. Atlantic Mills had 100,000 spindles in operation by the end of the century.

13

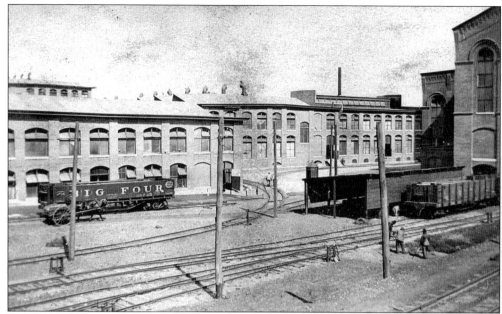

Arlington Mills, started in 1865, was located in the old Stevens piano case factory on the Spicket River. A dam was built on the Spicket west of Broadway with a dike north into Methuen. The original name was Arlington Woollen Mills. By the 1870s, the corporation had grown so much that it straddled the line between Methuen and Lawrence. Originally the mill produced both cotton and wool. The Arlington buildings are now home to Malden Mills, recently rebuilt after a devastating fire in 1995. (Courtesy the Forrest C. Hinckley collection.)

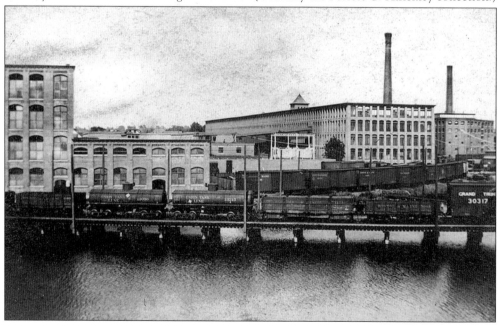

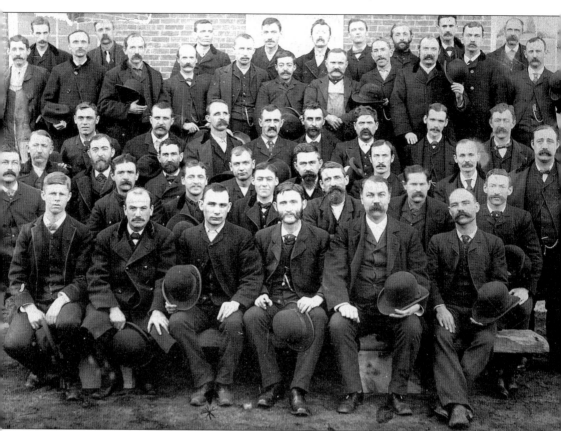

Other businesses in Lawrence were the Pemberton Company, the Lawrence Duck Company, the Farwell Bleachery, Prospect Worsted Mills, the Russell Paper Company, and the Cold Spring Brewing Company. All these corporations had more than $100,000 in stock. There were many more small industries in and around Lawrence. This picture shows the employees of the McKay and Bigelow Heeling Machine Association, which was located at the corner of Haverhill and West Streets. In 1895, the shop was bought by United Shoe Machinery and was moved to Winchester, Massachusetts.

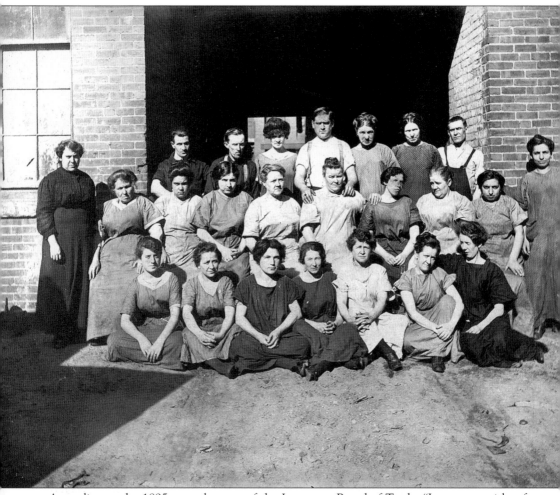

According to the 1895 annual report of the Lawrence Board of Trade, "Lawrence, with a few exceptions, has been happily exempt from strikes and labor troubles which have disturbed other manufacturing cities. As a rule its laboring classes are patient and reasonable in the adjustment of their rights, preferring peaceable arbitration to compulsory measures, which are always a setback to any business community. The large number of small property holders in our city, bear witness to the thrift and industry of its wage earners."

Two

THE CITY

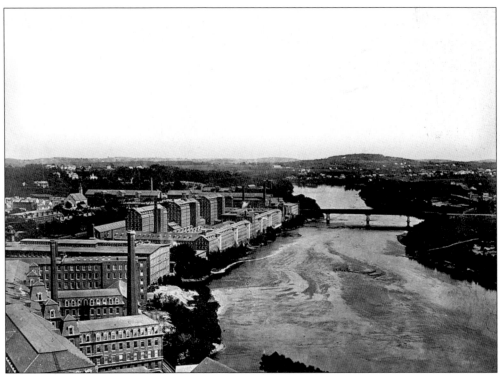

The Merrimack River is the reason the city of Lawrence exists. Its source is in the White Mountains of New Hampshire, and it drains an area of 4,400 square miles. Its entire length is 150 miles. In the 19th century, it ran through a series of industrial cities and towns, as did its tributaries. In the winter, the ice thickened to 18 to 24 inches and was the principal source of ice for the city—as well as recreation for skaters and the occasional horse race.

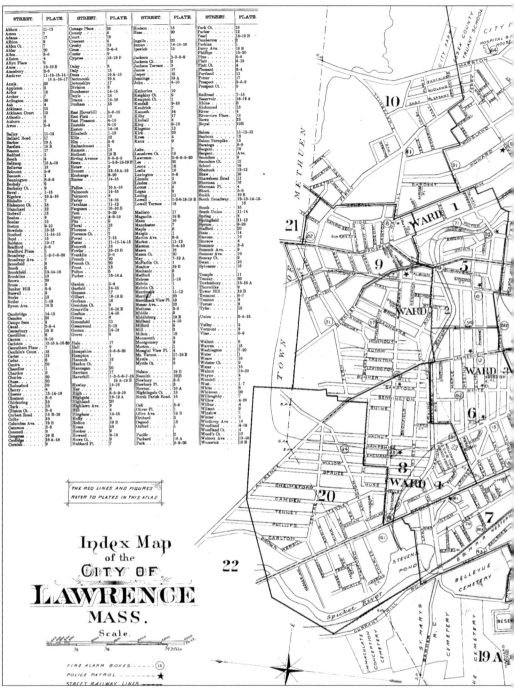

STREET	PLATE	STREET	PLATE	STREET	PLATE	STREET	PLATE
Abbott	11-12	Cottage Place	20	Hudson	18	Park Ct.	18
Acton	7	County	8	Huse	20	Parker	12
Adams	17	Court	18			Pearl	18-19 B
Albion	9	Crescent	6	Ingalls	20	Pemberton	2
Alden Ct.	7	Crosby	18	Inman	14-15-16	Perkins	1
Alder	20	Cross	5-6-8	Ipswich	15	Perry Ave.	19 B
Allen	3-6	Custer	6			Phillips	15-20
Alliston	4	Cyprus	18-19 B	Jackson	2-3-5-9	Pine	5-6
Allyn Place	9			Jackson Ct.	3	Platt	4-10
Amos	18-19 B	Daisy	8	Jackson Terrace	3	Platt Ct.	4
Amesbury	2-6	Daly	15	James	17	Pleasant	3-4
Andover	11-13-14-16	Dana	16 A-16	Jasper	9	Portland	11
	16 A-16-17	Dartmouth	19 A	Jennings	19 A	Potter	17
Annie	20	Devonshire	17	John	4-10	Prospect	3-5-9
Appleton	2	Division	4			Prospect Ct.	7
Arbor	18	Dorchester	14-15	Katherine	10		
Archer	2	Doyle	2	Keighley Ct.	8	Railroad	7-15
Arlington	20	Dracut	14-16	Kempton Ct.	1	Reservoir	18-19 A
Ash	4	Durham	18	Kendall	9-10	Rhine	4
Atkinson	13			Kendrick	7	Richmond	18
Atkinson Court	13	East Haverhill	8-9-10	Kenneth	16	River	8
Atlantic	2	East Platt	10	Kilby	2	Riverview Place	18
Auburn	6	East Pleasant	4-10	Kimball	4	Rowe	18
Avon	5-9	Eastside	4-10	King	9-10	Royal	19B
		Easton	14-16	Kingston	13		
Bailey	11-12	Elizabeth	1-18	Kirk	20	Salem	11-12-13
Ballard Road	17	Ellis	13	Kress	4	Sanborn	13
Barker	19 A	Elm	5-6	Knox	9	Salem Turnpike	15
Bartlett	19 B	Embankment	4			Saratoga	4
Beacon	17	Emmett	13	Lake	7	Sargent	10
Bedford	1	Endicott	19 B	Lacedown Ct.	18	Sargent Ave.	5
Beech	4	Erving Avenue	5-6-8-9	Lawrence	2-6-8-9-20	Saunders	2
Belknap	16 A-16	Essex	1-2-3-18-19 B	Lee	20	Saunders Ct.	1
Bellevue	18	Estaw	9	Lenox	16	School	18
Belmont	5-9	Everett	13-16 A-16	Leslie	10	Shattuck	12-13
Bennett	1	Exchange	8-20	Lexington	8-9	Shaw	16
Bennington	8-8-9	Exeter	14-15	Lincoln	2	Shawsheen Road	13
Berkely	6			Linden	18	Sherman	16
Berkeley Ct.	9	Fallon	16 A-16	Locust	4	Sherman Pl.	4
Beral	1-18	Falmouth	14-15	Logan	9	Sidney	19 B
Bigelow	16 A-16	Fairmont	4	Loring	1	Smith	19 B
Blakeslie	2	Farley	8	Lowell	1-2-6-18-19 B	South Broadway	19-13-14-16-
Blakeston Ct.	18	Farnham	11-12	Lowell Terrace	18		16
Blanchard	12	Ferguson	16-20			South	11-14
Bodwell	15	Fern	9-20	Madison	17	South Union	11-14
Boehm	9	Ferry	4-9-10	Magnolia	19 B	Spring	11-12
Border	15	Fitz	4	Mann	10	Springfield	8-20
Boston	9-10	Floral	18	Manchester	7	Spruce	8-20
Bowdoin	13-16	Florence	7	Maple	8	Stafford	20
Boxford	11-14-15	Florence Ct.	7	Margin	4	State	14
Boyd	15	Forest	7-18	Marion Ave.	6-6	Stevens	16
Boylston	10-17	Foster	11-13-14-16	Market	11-12	Storrow	4
Bradford	1-6	Foxcroft	15	Marston	3-4-10	Summer	3-5
Bradford Place	15	Fowler	16-25 B	Mason	18	Summer Ave.	9
Broadway	1-2-7-8-20	Franklin	2-6	Mason Ct.	20	Sumner Ave.	10
Broadway Ave.	7	French	20	May	7-19 A	Sunray Ct.	9
Brookfield	5	French Ct.	20	McFarlin Ct.	1	Swan	10
Brook	5	Front	13	Meadow	19 B	Sylvester	16
Brookfield	13-14-16	Fulton	6	Mechanic	4		
Brookline	10	Furber	16-16 A	Medford	1	Temple	4
Brown	20			Melrose	1-18	Tenney	20
Bruse	9	Gardon	3-4	Melvin	1	Tewksbury	16-16 A
Bunker Hill	3-9	Garfield	14-15	Melvin Ct.	1	Thorndike	2
Burwell	9	Genesee	17	Merrimack	11-12	Tower Hill	19 B
Burke	18	Gilbert	16-16 B	Merrill	20	Tremont	6-7
Butler	2	Gorham	16	Merrimack View Pl.	18	Trenton	4
Byron Ave.	19 B	Greichen Ct.	16	Mesner Ave.	20	Turner	4
		Granville	16-16 B	Methuen	2-3	Tyler	18
Cambridge	14-15	Grafton	15	Middle	1		
Camden	20	Green	6	Middleburg	19 B	Union	3-6-15
Campo Seco	7	Greenfield	11	Midland	4-10		
Canal	2-3-4	Greenwood	2-18	Milford	8	Valley	2
Canterbury	19 B	Groton	14-16	Mill	3	Vermont	1
Castilion	6	Grove	5	Milton	18	Vine	5-9
Caxton	9-10			Monmouth	4		
Carleton	12-16 A-16-20	Hale	17	Montgomery	4	Walnut	4
Carruthers Place	1	Hall	4	Morton	1	Warren	18
Caulkin's Court	18	Hampshire	2-6-8-20	Mongal View Pl.	4	Washington	7-20
Carter	2	Hampton	1	Mt. Vernon	17-16 B	Water	18
Cedar	6	Hancock	18	Myrtle	8	Weare	16
Centre	20	Hanlon Ct.	7	Myrtle Ct.	8	Webster Ct.	8
Chandler	2	Hannagan	20			Water	18
Chardon	6	Harrison	17	Nelson	19 B	Walnut	4-10
Charles	20	Haverhill	1-2-5-6-7-18	Nesmith	19B	Wayne	9
Chase	2		19 A-19 B	Newbury	3-5	Wendell	7
Chelmsford	20	Hawley	14-16	Newbury Pl.	4	West	1-7
Cherry	4	Hay	4	Newton	16 A	White	6
Chester	13-14-16	High	5-6-9-10	Nightingale Ct.	8	Whitman	20
Chestnut	5-6	Highgate	18-19 A	North Parish Road	16	Willoughby	6
Chickering	15	Highland	20			Willow	4-20
Clark	10	Highlawn Ave.	9	Oak	5-6	Wilbur	4
Clinton Ct.	5-8	Hildreth	8	Oliver Pl.	4	Wilmot	9
Corbett Road	16 B-16	Hingham	14-15	Olive Ave.	19 B	Winslow	1
Colby	10	Holly	8	Orchard	3	Winter	4
Columbia Ave.	19 B	Holton	19 B	Osgood	15	Winthrop Ave.	14
Common	2-3	Home	10	Oxford	7	Woodland	4-10
Concord	2	Hooker	8			Woodland Ct.	4
Congress	19 B	Howard	4-10	Pacific	2	Wood's Ct.	12
Coolidge	16 A-16	Howe Ct.	4	Packard	16 A	Wolcott Ave.	16
Cornish	9	Hubbard Pl.	7	Park	8-9-20	Worswick	19 B

THE RED LINES AND FIGURES REFER TO PLATES IN THIS ATLAS

Index Map of the CITY OF LAWRENCE MASS.

Scale.

FIRE ALARM BOXES (15)
POLICE PATROL ★
STREET RAILWAY LINES

This map is the first plate in the 1896 atlas of the city of Lawrence. The city is beginning to find its place in the Merrimack Valley. In May 1891, work started to replace track for horse-drawn trolleys with track for electric trolleys. The population topped 60,000 by the end of the century. Life was quite appealing for the aspiring middle class. The best neighborhoods still circled the common, Jackson Street, Haverhill Street, and Jackson Court, but the well-to-do had already started climbing up both Prospect Hill and Tower Hill. Almost exclusively,

18

individuals with Anglo-Saxon surnames owned property in the city. For the middle class, Lawrence provided many opportunities for a rich and full life. There was a wide range of goods, services, and entertainment to choose from. The city fathers seemed to feel that they could solve all of the issues confronting the city, ultimately providing an exemplary infrastructure that would tend to the needs of all classes.

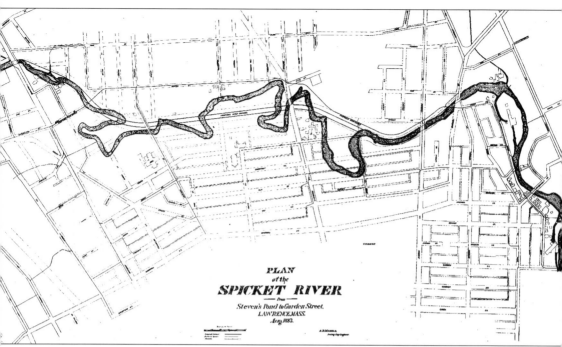

PLAN
of the
SPICKET RIVER
— from —
Steven's Pond to Garden Street.
LAWRENCE MASS.
Aug. 1883.

The Spicket River is a tributary of the Merrimack. The Spicket's source is Big Island Pond in New Hampshire. In 1883, when the city started making alterations in the river, the Spicket wiggled its way from the Arlington Mills to its mouth on the Merrimack with irregular banks and sluggish current. Twenty-four sewers, 70 house drains, and a number of privies, plus effluvia from a number of factories, emptied waste directly into the stream. According to an 1883 report of the Spicket River Valley Commissioners, the river was filled with "almost every conceivable kind of filth and rubbish incidental to an inhabited community." The city took on the task to straighten the river, as seen by this map.

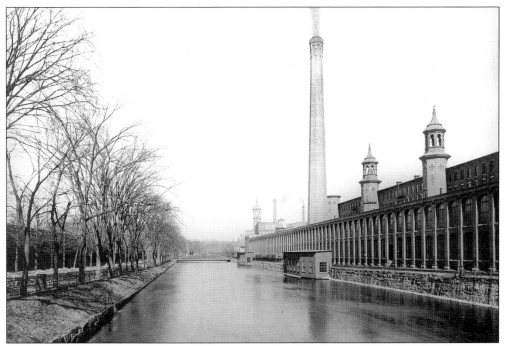

The North Canal was built at the same time as the Great Stone Dam. The entire canal was filled with water by 1848. The canal is 5,330 feet long.

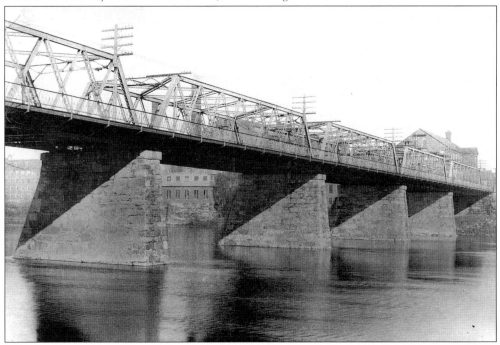

The Lawrence Bridge opened for business in 1855. It was run as a toll bridge until 1868, when it and the Andover Bridge became free to the public. The Lawrence Bridge was destroyed by fire and rebuilt in iron in 1887. This is the bridge that connects north and south Union Streets. It is often called the Duck Bridge due to its proximity to the mill where duck fabric was manufactured.

The Andover Bridge was the first to span the Merrimack in Lawrence. Initial construction was in 1793 at what was then called Bodwell's Falls. There were many repairs and rebuilding for the next 50 years until 1846, when the bridge was absorbed into the Essex Company. Floods continued to cause damage. The bridge (left) was a toll bridge until 1868, when it became free to traffic as part of a public highway. Andover Bridge was destroyed by fire in 1881 (below) and was replaced by an iron bridge.

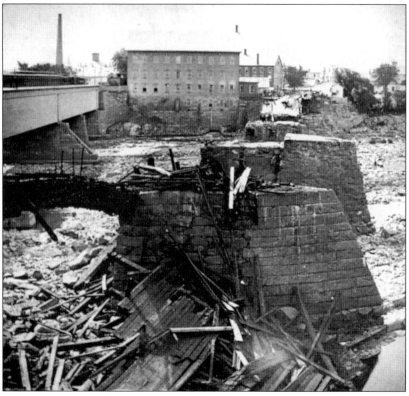

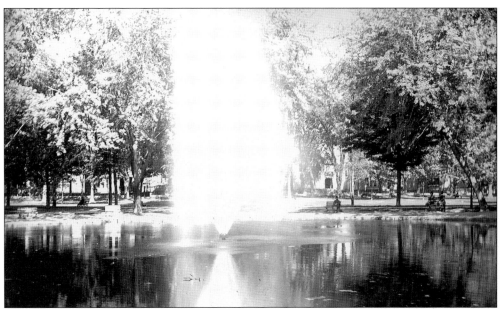

For 25 years, the citizens of Lawrence used wells and cisterns to obtain water for domestic use. In 1848, John Tenney of Methuen, Alfred Kittredge of Haverhill, and Daniel Saunders of Lawrence formed a corporation called the Lawrence Aqueduct Company to bring water in from Haggett's Pond in Andover. Three years later, the Bay State Mills and the Essex Company built a reservoir near the top of Prospect Hill. The Lawrence Reservoir Association, consisting of several corporations, owned this property. Each company had its own system of pipes, and the entire distribution system supplied the needs of most businesses as well as the Common Pond (above). In 1871 and 1872, Henry Barton and other citizens argued for a municipal water supply, and after investigation, the Merrimack River was chosen to be its source. A pumping station (below) and a new reservoir (on Tower Hill) were constructed between 1874 and 1875.

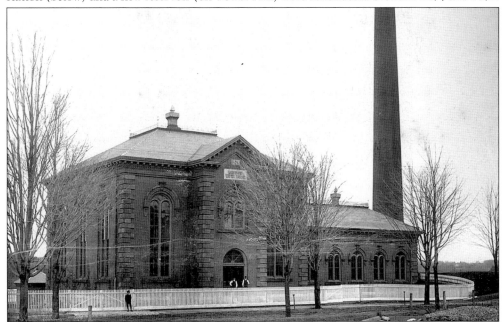

In 1893, the first municipal filtration system for the elimination of bacteria in the United States was established at this pumping station. The reservoir had a capacity of 40 million gallons. A newly constructed filter bed took the water of the Merrimack above the dam and conducted it through 69 miles of pipe. Average consumption was three million gallons per day. The city was proud of its state-of-the-art water system, which was, according to the Lawrence Board of Trade, "patterned after the best systems in Europe and conceded to be one of the finest on earth." This photograph shows men of the water department clearing the filter beds at the pumping station. The two men in the foreground are supervisor Alfred Marsden (left) and payroll clerk Tom Anderson. Superintendent Lewis P. Collins is at the far right.

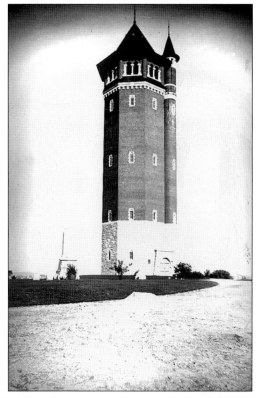

The reservoir on Tower Hill was built in 1875. In order to serve higher elevations in the city, a water tower was needed, and a steel tank (102 feet in height with a capacity of 528,000 gallons) was built in 1895 for this purpose. Despite dissension due to the expense, the standpipe was enclosed in brick and stone. Fortunately for the neighborhood, the yeas won and the metal standpipe ($6,000) was covered with brick ($11,300). The finished building had an observation gallery, an iron stairway, and a copper-covered conical roof. From the gallery, one could see for 60 miles.

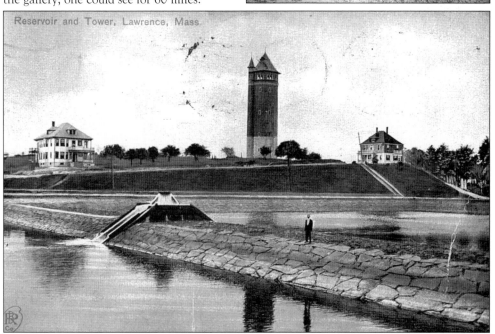

Reservoir and Tower, Lawrence, Mass.

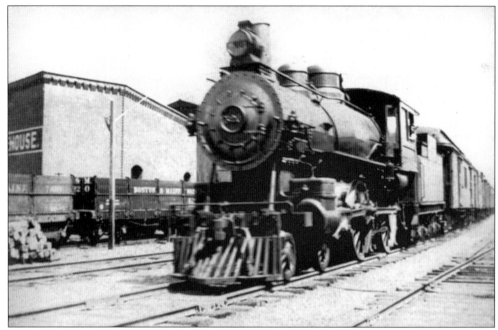

By the end of the 19th century, there were 80 miles of streets in the city, and many were being paved. Six railroad lines radiated from Lawrence to all parts of New England. Seventy-six passenger trains ran to and from the city over the Boston and Maine Railroad. This Hinckley photograph shows a train passing through Lawrence on the route from Boston to Manchester, New Hampshire. (Courtesy the Forrest C. Hinckley collection.)

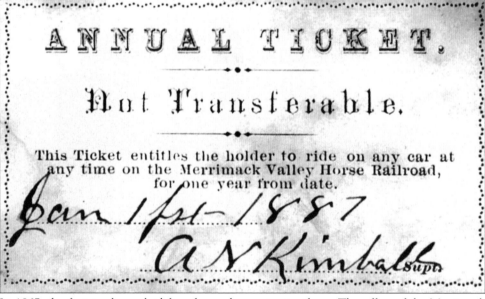

In 1867, the first track was laid for a horse-drawn street railway. The office of the Merrimack Valley Horse Rail Road Company was at 563 Essex Street. Electric streetcars were introduced in 1891, and rail routes covered the city and connected Lawrence with other communities. Fred Morgan, a member of the Lawrence Fire Department, owned this annual pass.

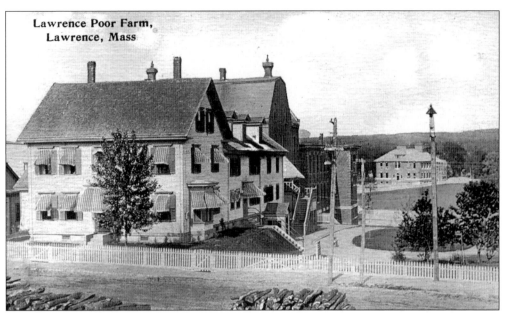

Lawrence Poor Farm,
Lawrence, Mass

The Lawrence Almshouse and Cottage Hospital were located on Marston Street on an area of open land suitable for agriculture. The almshouse opened in 1849 with seven people initially admitted. By the end of the century, the number of residents was closer to 100 or more.

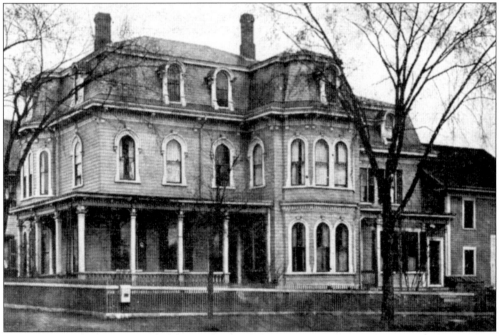

In 1895, representatives from various charitable groups in the city met at the hall in the Lawrence Public Library to discuss the formation of a society to provide a suitable home for the elderly. The result was the incorporation of the Lawrence Home for Aged People. Some months later, Mary A. Wood granted the corporation her home at 4 Bailey Street in South Lawrence. She continued to inhabit certain areas of the house, with the rest being used as the Wood Home for Aged People. The home was occupied by a number of the elderly in 1899.

A CHANCE OF A LIFETIME.

100 CHOICE BUILDING LOTS TO BE SOLD AT ONCE BY PRIVATE CONTRACT

—AT—

BODWELL PARK, TOWER HILL.

Finest Place to Live Within City Limits. Main Sewer. City Water. Well Planned Streets and Avenues.
"Electrics" Pass Every Few Minutes. Ten Minutes Walk Only to Boston & Maine Depot.

PRICES VERY LOW. TERMS REASONABLE. FIRST COME--FIRST SERVED.

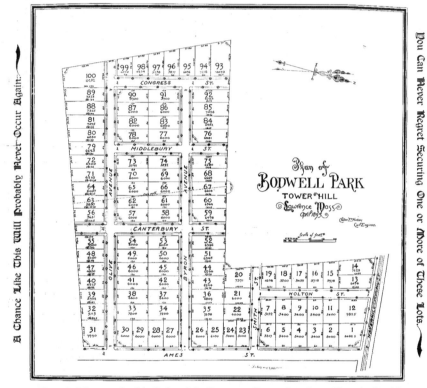

Magnificent Views Amid Splendid Surroundings in the Finest Residential Portion of Lawrence.

WE SHALL BE GLAD TO SHOW YOU AROUND AT ANY TIME. APPLY TO

S. B. Bodwell, 589 Haverhill Street, Lawrence, Mass.,

—OR TO—

Wm. R. Pedrick, Office, 361 Essex Street or Residence 760 Essex Street.

There were many areas of the city's seven square miles that had not been developed, but most streets were already named and building lots were being divided up. Some 250 structures were being built every year. Housing developments were springing up in a number of locations. One such plan (shown here), called Bodwell Park by the realtor, was located on lower Tower Hill between Ames and Congress Streets. Kearsarge Heights was another development, situated behind the Tower Hill Reservoir. The developers boasted that it was the highest elevation in the city and had a magnificent view of Mount Kearsarge and Mount Monadnock in New Hampshire.

28

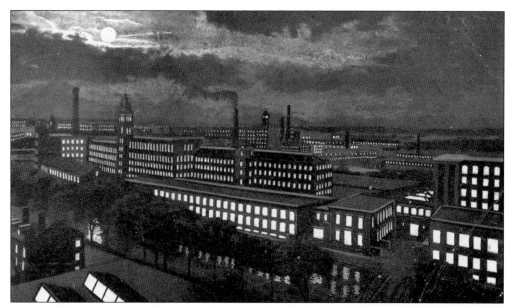

The first electric lights installed were large arcs on the common in 1880. The Lawrence Electric Lighting Company was organized in 1886 with Gen. M. P. Merrill as president and W. E. Heald as treasurer. Before the advent of electricity, the city was illuminated by gas and kerosene. A cadre of lamplighters lit the street lamps every night and extinguished them the next morning, and the police carried matches to relight lamps that had gone out. If the moon was full, the lamps were not lit. This postcard shows the mills at night under electrical power.

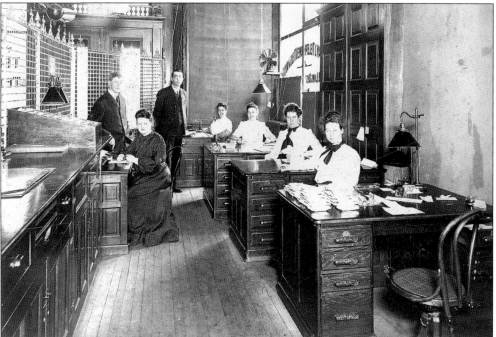

Some 300 miles of telephone wire supplied service to 450 subscribers in 1895. This photograph shows the local office of the New England Telephone and Telegraph Company. (Courtesy Joe Bella.)

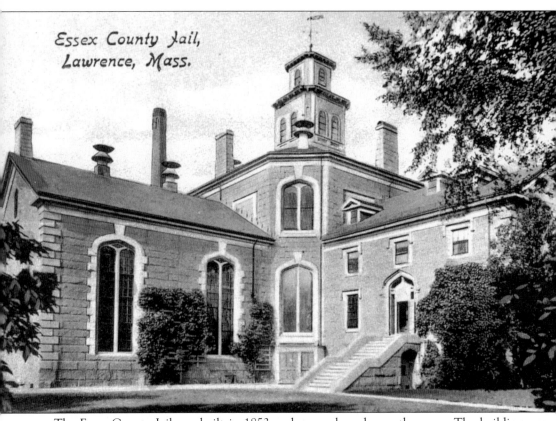

Essex County Jail,
Lawrence, Mass.

The Essex County Jail was built in 1853 and was enlarged over the years. The building was constructed of granite, the main portion being an octagon with wings extending northeast and west. It had 116 cells to house 180 prisoners. Gridley J. F. Bryant was the architect for both this building and Boston's Charles Street Jail (built in 1851). The two jails were remarkably similar and reflected the Auburn system of cellular confinement. Developed in New York in the 1820s, the system allowed inmates to interact with each other during the day and required them to return to individual cells at night.

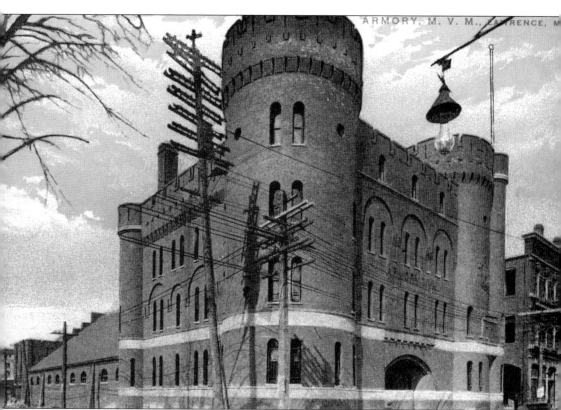

Nine state armories for militia purposes were constructed under an act of the legislature approved in 1888. (Before that, the militias used the largest halls that the community could provide.) The Lawrence State Armory was built on Amesbury Street in 1892 as part of this program. As in many other communities in Massachusetts, the armory looked like a castle and housed two artillery companies and one regiment of infantry. It was of medium size compared to other armories. The interior was finished in oak and ash and included officers' and company rooms, drill and gun sheds, a shooting gallery, and a mess hall. The main hall was used well into the middle of the 20th century for public functions. In the 1960s, the building came down during urban renewal.

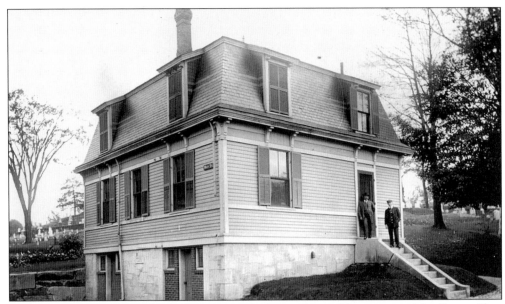

Bellevue Cemetery was established in 1847 with the purchase of five acres on May Street. Plots sold for $5 apiece. The cemetery grew to 35 acres by 1891. The Betsy Ross Chapter of the Daughters of the American Revolution (DAR) completed an index of Bellevue graves from 1847 through 1899. The building in this picture is the hearse house, designed by M. and W. B. Perkins and built by James Flanagan in 1873.

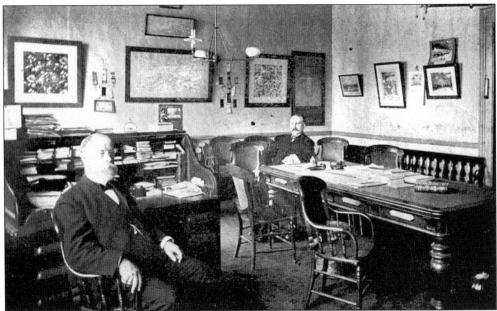

The Lawrence Board of Trade, organized in 1888, encouraged various physical improvements to the city and worked to bring in new businesses. It also offered social activities to its members and their families. The board's 1899 annual report read, "It is non-sectarian and non-political and welcomes to its rolls and membership, men of all creeds, nationalities and political beliefs. The only test of membership, aside from the trifling annual fee, is that the applicant will attend the meetings and work for the growth and progress of the 'Queen City of the Merrimack.' "

THIRD ANNUAL REPORT

TO THE

PATRONS AND FRIENDS

OF THE

LAWRENCE CITY MISSION.

————•◦•————

On the evening of Feb. 26th, 1859, at a regular meeting of the LAWRENCE PROVIDENT ASSOCIATION (an organization that had been in existence in our city for four years, that had its visiters in each Ward, its regular monthly meetings, and had accomplished much good in relieving the destitute), the following resolution was passed :

Resolved,—" That a committee of two from each religious society in the city, be invited to meet in Convention with a committee of two from this Association, to take into consideration the subject of establishing a City Mission."

Rev. Geo. Packard, *President*, and Dr. W. D. Lamb, *Secretary*, represented the Association. In answer to this call, a meeting of twenty-six delegates was held on March 3d, and after a unanimous expression in favor of the project, a sub-committee was appointed to present, at a future meeting, a plan of organization. In the report of this committee, presented by Charles S. Storrow, chairman, the following plan was presented, and unanimously adopted.

The Lawrence City Mission, at 206 Essex Street, came into being in 1859, with Charles S. Storrow as chairman. The following statement appeared in the mission's annual report: "[To be free of bias for the purpose of] friendly council, encouragement and material aide to the poor and friendless, is a measure that promises results of a most beneficial character not only to those who are to be particularly the objects of the labors of the Mission, but also to those who, by joining in its support whatever may be their peculiarities of religious opinion, thereby create and strengthen between themselves that bond of true Christian fellowship which unites all who co-operate in a good work."

LAWRENCE CITY MISSION.

GILBERT E. HOOD, President.
JAMES H. KIDDER, Treasurer.
CLARK CARTER, Secretary.

OFFICE. 206 ESSEX STREET.

July 20, 1896.

Mr. *F. E. L'eage*

DEAR SIR:-

At a special meeting of the Lawrence City Mission held July 9, for the purpose of considering the emergency caused by the present business depression and our exhausted treasury it was voted to instruct the Secretary to make a personal solicitation of funds.

We need at least six hundred dollars to carry our work to the first of October.

The cases mentioned below are a few of the many demanding relief:

(*a*) Nine in the family; after three weeks of compulsory idleness two girls have returned to work at 40 hours per week.

(*b*) An aged couple; the man has been earning $3 or $4 a week, but is laid off till September.

(*c*) A family of eight; the father is earning a dollar a day, the only child old enough to work is sent out for eight weeks.

(*d*) A widow with five children is out of the mill to nurse one of them through a severe illness; one boy is earning four dollars a week.

Whatever sum you are at liberty to contribute towards this amount will be gratefully received, and will be carefully used to relieve real distress.

Respectfully yours,

CLARK CARTER, Secretary.

The Lawrence City Mission appointed George P. Wilson as missionary. All the churches would collect a relief fund that was placed in the hands of the missionary for charitable purposes. The mission set right to work ministering to the "poor and erring" by giving material and spiritual aid, "guarding against giving too much, lest the incentive for constant exertion be taken away." These activities included gathering the poor into the houses of worship, Sabbath schools, and day and evening schools while furnishing clothing, employment, and Bibles. The mission also visited the sick, the jail, and the almshouse. By 1885, the mission had become a clearinghouse for charitable activities to assist the deserving poor, raise the needy above the need for relief, prevent begging, and diminish pauperism.

34

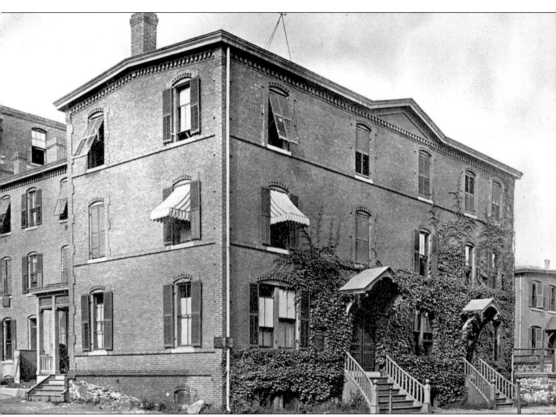

The Ladies' Union Charitable Society was incorporated in 1875 "to receive and care for infant children, and for general hospital work." These women had previously volunteered their time for a flower mission—that is, providing flowers, hospital supplies, and jellies and fruit for the sick. A call was made from various pulpits for the public to meet at city hall to help the women find a place described in the society's annual report as "suitably furnished under the care of a matron, to which little children could be brought in the morning by mothers, and left during the day while they were at work, and from which to be taken again at night on the mother's return from toil." The nursery was located at the corner of Methuen and Jackson Streets, and it was not long before the day nursery was receiving children who needed a permanent home. It would eventually become a children's home.

THANKSGIVING BAG.

ANNUAL DONATIONS

TO THE

★HOSPITAL★

AND

DAY NURSERY,

**INSTITUTIONS FOR THE SICK PERSONS AND HOME-
LESS CHILDREN OF LAWRENCE, ANDOVER, NORTH AN-
DOVER AND METHUEN.**

WHAT WE NEED.

Sugar, Tea, Coffee, Flour, Beans, Raisins, Butter, Lard, Ham,
Beef, Pork, Chickens, Potatoes, Apples, Vegetables of all sorts,
Oil, Molasses, Wood, Coal and sundries.

Please bring your bag to the Hospital and Nursery Building,
No. 95 Methuen Street, near the rear of the Post Office, on Friday
or Saturday, Nov. 21st and 22d, from 9 o'clock A. M., to 8 o'clock
P. M. Persons bringing Bags are respectfully invited to inspect

THE HOSPITAL AND NURSERY.

"God loveth the cheerful giver."
"Thou shalt open thine hand wide unto thy brother, to thy
poor and to thy needy in thy land."
"Give alms, provide yourselves Bags, which wax not old a treasure
in the heavens."
"Blessed is he that considereth the poor."

Lawrence, - 1885.

The May Breakfast started as a fundraiser by the women of the Garden Street Methodist Episcopal Church in conjunction with the Ladies' Union. By the close of the 1900s, the women had funded the Lawrence General Hospital with its 30 beds, the children's home that could accommodate a maximum of 18 children, and a training school for nurses. The Thanksgiving Bag Committee started in the late 1880s. Brown paper bags printed with instructions were distributed throughout the city. Grocer William Currier and provision dealer George Webster donated bags. Patrick Sweeney, the owner of the Lawrence Journal, printed the bags for free. Some 1,000 bags were distributed in 1889, and the city responded with money and a variety of provisions.

Three

CELEBRATIONS

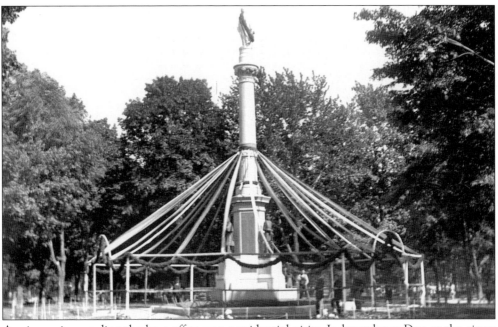

Anniversaries, sending the boys off to war, presidential visits, Independence Day, or the circus coming to town were among the celebrations in Lawrence. At the end of the 19th century, the city hosted 10 or more parades each year. Memorial Day was a product of the Civil War, and Lawrence set aside a day in the spring to remember the war dead. Labor Day became a local holiday in the late 1880s. Schools, businesses, and factories closed for the day, which allowed families to have picnics in the local parks and to line the streets to watch a parade. St. Patrick's Day was celebrated as early as the 1860s and usually included a parade. The French Canadians celebrated St. Jean Baptiste Day in June. Firemen's musters would bring engines from surrounding towns, and carnivals were held on the Merrimack River. This photograph, taken from a glass-plate negative, shows the Soldier and Sailor's Monument on the common. One of the last events of Memorial Day was a final trip to the monument after church services, family gatherings, and parades where speeches were given. The monument was decorated with bunting.

The Memorial.

No. 4, Vol. 1. Lawrence, May 30th, 1885. PUBLISHED BY JAMES L. BOLDUC.

AND AGAIN!

Another special party will leave Lawrence, for all points in

Iowa, Wisconsin, Missouri, Kansas, Colorado, California, Dakota, Minnesota &c., &c.

Wednesday, June 10th, 1885.

An Elegant Wagner Sleeping Car from Boston to Chicago without change, via Boston & Albany, New York Central and Michigan Central Rys. will be furnished

FREE ! FREE !

To holders of first-class tickets purchased before June 9. For particulars, time tables maps and accommodations, call personally or address.

H. D. BLAISDELL,

TICKET AGENT,

B. & L. Depot, Lawrence, Mass.

J. Moses & Co., Fine Rubber Stamps Autograph and Monogram Stamps a specialty, 409 Broadway, Lawrence.

The best place in Lawrence

—TO GET A—

LUNCH

—IS AT—

JOHN F. FINN'S

42 AMESBURY ST.,

LAWRENCE, MASS.

Imported Kaiser at the Windsor.
La Rosa Respecta Cigars at the Windsor.

MEMORIAL DAY

SATURDAY, MAY 30th, 1885.

Comrades report for duty at 7 o'clock A. M., on memorial day, and take the 7.30 car for North Andover, and assist our comrades there in decorating graves.

LINE FORMED AT 8 O'CLOCK.

A Collation will be served to all who attend.

You will assemble again at 1.30 P. M. The line will be formed on Essex Street, right on Appleton.

—THENCE TO CITY HALL.—

ORATION

—BY—

COL. JOHN P. SWEENEY,

—AT TWO O'CLOCK.—

Singing by the High School.

After the oration the Companies will take their baskets of flowers and form in line on Lawrence St., Company M will preform escort duty.

—LINE OF MARCH.—

Essex to Jackson, Haverhill, Franklin and Cross, to G. A. R. lot. Return through Manchester, Broadway and Essex. Line dismissed front of Needham Hall.

Let every member be on duty, in full G.A.R Uniform

—PER ORDER OF—

FRANK O. KENDELL, JAMES J. STANLEY,
Adjutant. *Commander,*

FRENCH, PUFFER & CO.,
ARE SELLING THE BEST

TOILET SET

FOR $3.00

Ever offered in Lawrence at that Price.

E. A. FISKE Room Papers and Window Shades, Artists' Materials, Lamps, Fringes, &c., 275 Essex Street, Lawrence, Mass.

C. BELDEN SMITH,

KEEPS THE BEST AND LARGEST STOCK OF

CONFECTIONS

To be found in the city. Also

FRUIT OF ALL KINDS

Nice Soda, Good Cigars, &c.

PRICES EQUAL TO THE TIMES.

109 Essex Street, Lawrence, Mass.

Game of Base Ball with Cards

AND OTHER GAMES.

BATS AND BALLS, CROQUET CHEAP, CARTS AND WHEELBARROWS,

—AT—

BLANCHARD'S

Stationery and Blank Book Store

57 BROADWAY.

La Normandi Cigars at the Windsor.
Henry Clay Cigars at the Windsor.

Imported Kaiser at the Windsor.
La Rosa Respecta Cigars at the Windsor.

Wm. W. Barrie,
241 ESSEX STREET.

CIGARS AND TOBACCO

AT WHOLESALE AND

RETAIL.

Humans everywhere have set aside days of remembrance of those who have died, by cleaning cemeteries and decorating graves. Memorial Day (Decoration Day) started to become a national celebration in the decades after the Civil War. Spontaneous days of remembrance seemed to spring up on both sides of the Mason-Dixon Line in towns on different dates. The South held events earlier in May; the North leaned toward the end of May.

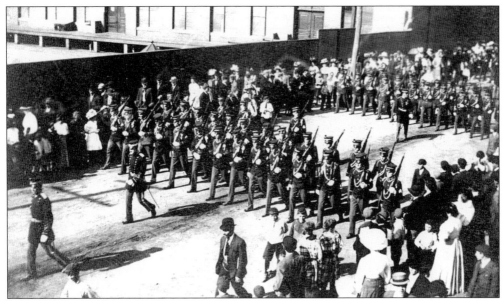

The city of Lawrence has celebrated anniversaries at many different times. Incremental celebrations to coincide with the building of the dam (1845), incorporation as a town (1847), and becoming a city (1853) have all been used at different times. In 1872 (on the 25th anniversary as a town), residents started thinking back to the city's beginnings. The first large celebration took place in 1895 at the 50th anniversary of the dam. In September of that year, schools and industry closed and the governor was greeted with a 17-gun salute. Shown in the above photograph from the Hinckley collection is Company F, 9th Regiment of the Massachusetts Volunteer Militia, marching in one of the parades. A ball in city hall and the inevitable fireworks followed parades, concerts, and athletic competitions. Below is of one of the buildings (Slater Plumbing, on the corner of Hampshire and Essex Streets) on the parade route all decked out in bunting. (Courtesy Joe Bella.)

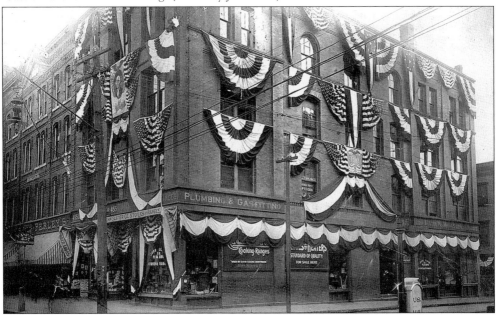

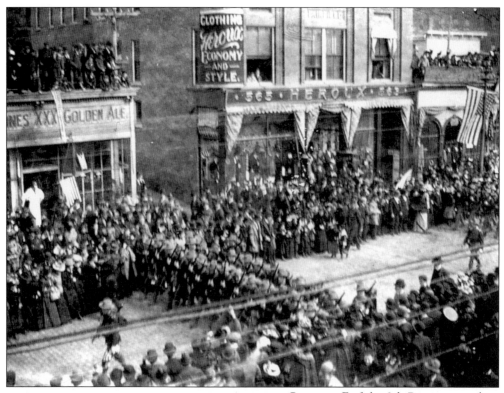

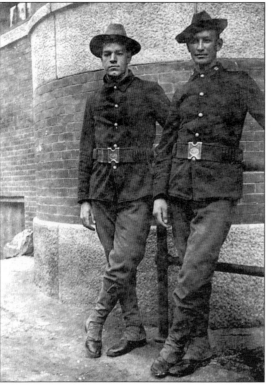

Company F of the 9th Regiment and Company L of the 8th Regiment of the Massachusetts Volunteer Militia represented the city of Lawrence in the Spanish-American War. Both companies were mustered on May 4, 1898. Company L went to Chicamauga, Georgia, and Company F to Camp Alger, Dunn Loring, Virginia. The 9th Regiment would witness the surrender of Santiago. The photograph above shows Company F marching from the armory to the railroad station on May 4, 1898, to the boom of cannons and the strains of "The Girl I Left Behind Me," with 20,000 people waving flags and cheering for the city's first volunteers sent off to war since the end of the Civil War. The photograph to the left shows two unidentified soldiers.

Independence Day was a big event for the city for nearly every year from the first celebration in 1848. By the 1890s, programs were printed by local merchants and used as advertising. The days would start with the city's churches ringing their bells at sunrise. The children would have separate entertainment in the parks and in city hall. There were often competitions, such as three-legged races, and athletic events, such as regattas and baseball games. There was always a parade ending in fireworks on the common.

The Official Programme.

JULY 4th, 1890.

AUTHORIZED BY THE COMMITTEE AND PUBLISHED BY THE LAWRENCE ONE-PRICE CLOTHING COMPANY.

Lawrence One-Price Clothing Company,

431 --- ESSEX STREET. --- 431

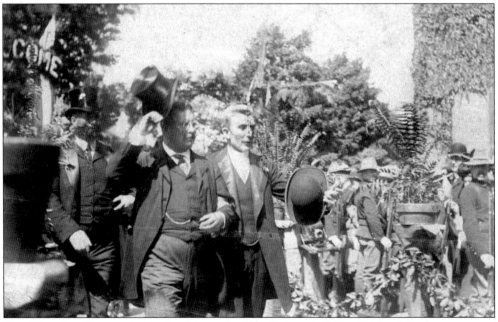

Pres. Theodore Roosevelt (tipping his top hat) made a tour of New England in the summer of 1902. After visiting Lowell, Boston, and Lynn on August 26, he arrived in Lawrence by train. Mayor James F. Leonard (with the bowler) met the president. Needham Post No. 39 of the Grand Army of the Republic escorted the president and members of the city government to a platform between the station and Broadway. A crowd of 20,000 cheering citizens greeted the president, who spoke about the area's unique contribution to the nation.

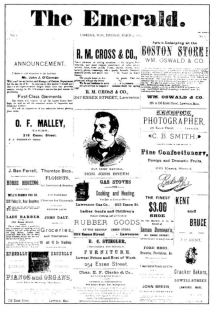

St. Patrick's Day was celebrated in Lawrence as early as 1868. These celebrations always had a significant religious element but also included social events and the inevitable parade. This newsletter, the *Emerald,* would have been distributed to the public. The center illustration is of John Breen, the first Irish Catholic mayor and the marshal for the day's events.

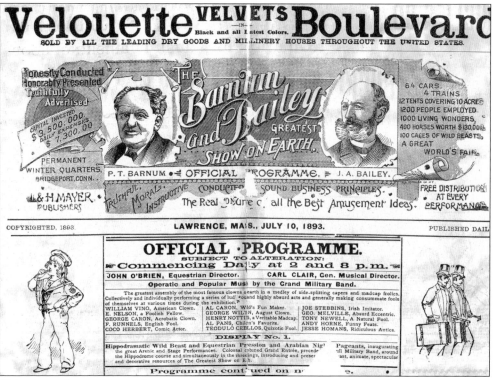

This circus featured just what you would expect—trained animals, jugglers, trapeze artists, hippodrome races, lots of clowns, and the "greatest of all death defying deeds of Cyclo, the Keinetic Demon." It arrived on five railroad trains (an event in itself), and as tents were pitched in South Lawrence, the cooks were already making breakfast for 1,100 employees. Circus day started with a parade. Ticket holders could enter an hour early to view the animals and "peculiarities of human prodigies." The tent held 16,000 people.

Four

RELIGION IN
THEIR LIVES

There were 35 churches located throughout the city by 1899. Episcopal, Methodist, Congregational, Baptist, Unitarian, Universalist, Presbyterian, and Roman Catholic made up the major denominations, but smaller congregations included the Advent Christian Church, the Religious Society of Friends, the Church of Christ Scientist, and the Swedenborgians. As in most communities in New England, the Protestant spires predominated and the majority of citizens attended a church. This postcard of the First Methodist Episcopal Church is looking east toward St. Mary's.

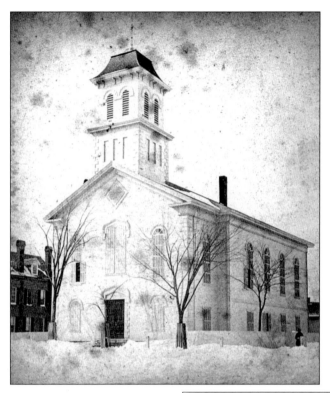

The First Methodist Episcopal Church was started in 1846 with the appointment of Rev. James L. Slason. The building in this stereo slide was built in 1848 and was located at the corner of Haverhill and Hampshire Streets. It was originally called the Haverhill Street Methodist Episcopal Church, but its name was changed in 1892. This church was the first of all the Methodist churches and sent out missions that resulted in both the Parker Street Church and St. Mark's.

The Bodwell Street Methodist Episcopal Church began as a mission Sunday school of the Haverhill Street Church at the corner of Bodwell and Margin Streets in 1878. The following year, a church was organized in the same building, but the name was changed to St. Mark's Church. The new building, seen here, at the corner of Essex and Margin Streets, was dedicated in 1890.

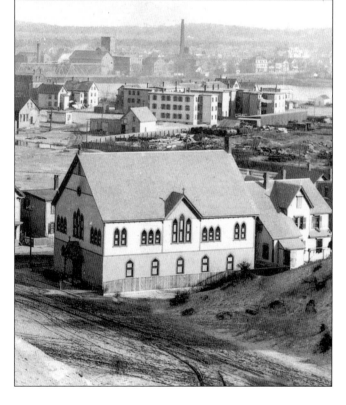

Another Methodist Episcopal church in Lawrence was St. Paul's on Wyman Street. It began as the Arlington Union Church at the Lake Street Chapel in 1885. The congregation affiliated with the Methodist denomination in 1891, taking the name of St. Paul's. A new building, seen in this drawing, was built in 1895 at the corner of Arlington and Wyman Streets.

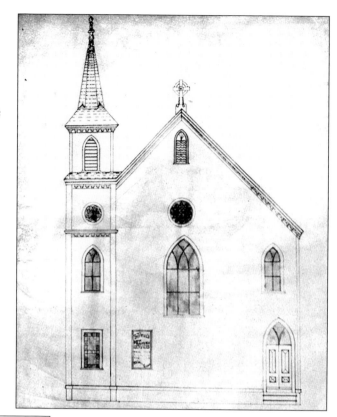

Yᵉ Muficke ọf Yᵉ Olden Tyme.

Yᵉ GREATE

OLDE FOLKE'S SYNGE.

Also some Speaking and worldlie Songs by yᵉ Folkes from North and South Side of Thyse Towne, at yᵉ

Garden Street Meetynge House,

WEDNESDAY, yᵉ 9th Daye of yᵉ 4th Monthe.

To Wit: Apr. A.D., 1890. N. S.

Yᵉ Latch-strynge of yᵉ Meetynge House fhall be hung out at earlie candle-lite, wʰ is 7 of yᵉ Towne Clock, by direction of yᵉ olde Farmer, hys Almanack.

Yᵉ inftruments of mufick fhall begin to founde at 7.45 of yᵉ clock.

At close of yᵉ Concert yᵉ Wimmen fingers will go to yᵉ Vestry and serve yᵉ people with refreshments for ten pennies.

Tyckettes 25 Çents.

Pyck'd Seates. Same pryçe.

Come earlie and get pyck'd seats.

N. B.—All yᵉ goode folkes wʰ hope to attend yᵉ Greate Concerte of Muficke wyll buy yᵉ Tyckettes without delay.

Piano used at this concert from Kennelly & Sylvester.

The Garden Street Methodist Episcopal Church, organized in 1853, was situated at the southwest corner of Garden and Newbury Streets. The church was originally called the Second Methodist Episcopal Church. Many May Breakfasts of the Ladies' Union Charitable Society were held here. In all, there were six Methodist Episcopal congregations in Lawrence.

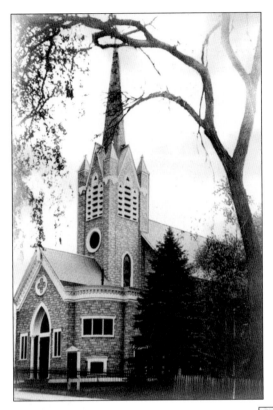

The German Methodist Episcopal Church, founded in 1878 by a group of German congregants at the Garden Street Church, was dedicated at Vine Street in 1881. The name was changed to the Vine Street Church in 1942. Prayer meetings, led by Rev. D. C. Knowles of the Haverhill Street Church and Rev. C. U. Dunning of the City Missionary Society, began in 1868. Parker Street Methodist Episcopal Church was organized in 1870, meeting on Blanchard Street until relocated in the building on the corner of Parker and Abbott Streets, seen here. (Courtesy the Lawrence History Center.)

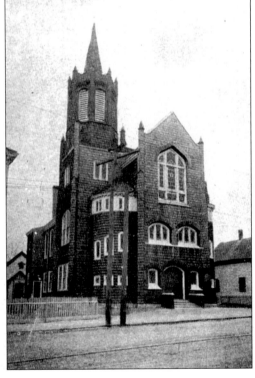

There were two Presbyterian churches in Lawrence. The United Presbyterian Church was a Scottish church located on Concord Street. The German Presbyterian Church (shown here) started in 1872. Previous to this date, German Presbyterians worshiped at Trinity Church, but they purchased land on East Haverhill Street in 1875 and erected a one-story building. The church in this postcard was built in 1900. (Courtesy Joe Bella.)

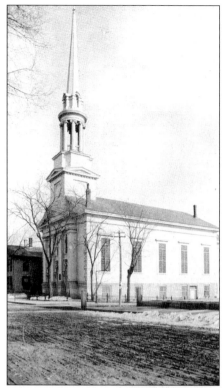

The first meeting to form a Baptist community was held in 1847. That same year, the Amesbury Street Baptist Church was formally organized and services were held in an old schoolhouse near the site of the First Methodist Episcopal Church. The first baptism was held in the Spicket River in 1848. The building to the right was dedicated in 1850 at the southeast corner of Amesbury and Haverhill Streets on land donated by the Essex Company, and the church became the First Baptist Church. The Second Baptist Church, seen below, and the First Free Baptist Church were located on Common Street. (Courtesy Joe Bella.)

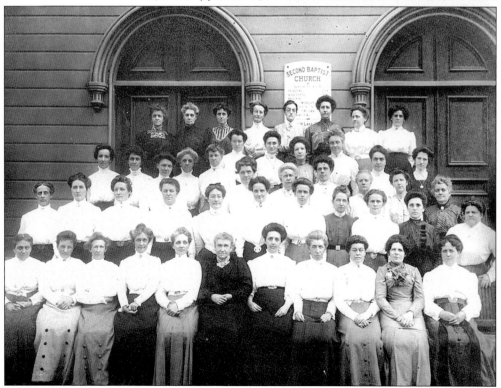

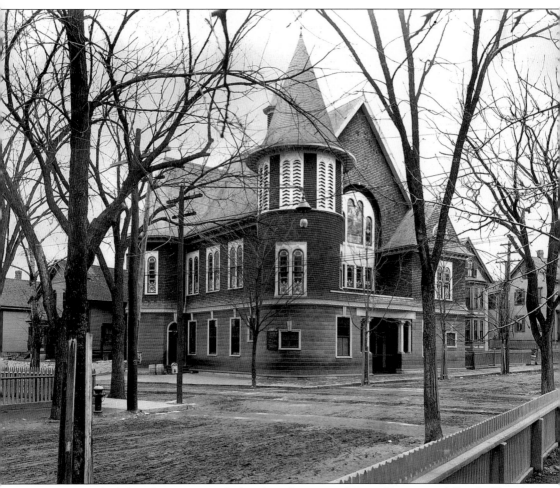

Lawrence had five Congregational churches: Lawrence Street, Trinity, and South Churches and the United (seen here) and Riverside Churches. The three Episcopal churches were Grace, St. John's (on Bradford Street), and St. Thomas. Apart from weekly church services, parishioners were encouraged to attend all kinds of religious and charitable groups. The devout worried about the constant lure of temptation. William Lawrence, the pastor of Grace Episcopal Church during the 1880s, expressed it this way: "Lawrence was full of sin and needed the Gospel." (Courtesy the Lawrence History Center.)

The first mass celebrated in what was to become Lawrence was at Michael Murphy's house, at 7 Newton Street, in South Lawrence in 1845. Immaculate Conception Roman Catholic Church was a small wood-frame church on Chestnut Street not far from the later church. *Catholic Church of New England* relates, "There the exiled children of St. Patrick's assisted at the Divine Mysteries, and were instructed by countrymen of their own in the duties of the faith which they had brought, bright and unblemished, from the Island of Saints across the waves of the broad Atlantic to this land of religious freedom." The brick church shown here was built in 1855.

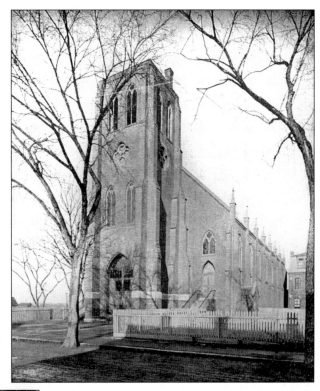

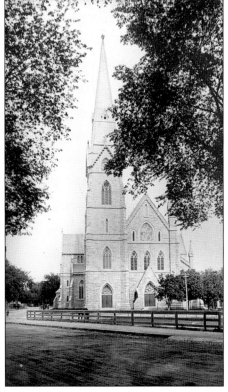

The proper title for St. Mary's is Church of Our Lady of Consolation Catholic. It is the largest (and, some would say, the handsomest) church structure in the city. The original parish met in a half-finished wood-frame structure on the north side of Haverhill Street the first Sunday in 1849. In 1853, a new granite church replaced the first one, and a school was added. The structure in this photograph was dedicated in 1871.

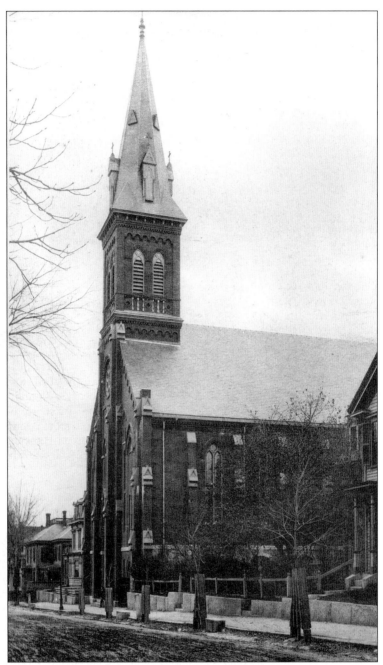

About 1,000 French Catholics celebrated their first mass on Christmas Day 1871 in Essex Hall. For the first few years, all of the priests came from Lowell to perform the mass. In 1873, Fr. Joseph E. Michaud moved his residence to the city and construction of the French church began. Although the church was unfinished, divine services commenced in the basement under the patronage of St. Anne. St. Anne's was finally finished and dedicated on Low Sunday 1883. The St. Anne's of this period stood on the north side of Haverhill Street just west of St. Mary's. It was in the Gothic style in brick with freestone trimmings. It was familiarly called "the French Church." A school for boys and girls was soon added.

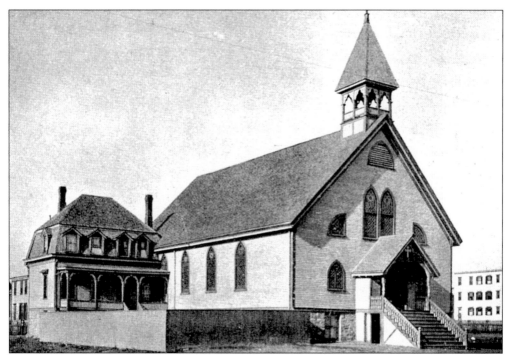

German Catholics attended mass at the surrounding churches and were visited by Jesuit Fathers from Boston, who would hear confession and preach to them in their native tongue. Throughout the 1880s, meetings were held to raise funds to build a church and to procure a priest who could speak German. The church was built and the first service was held in 1888. That same year, a school was started under the teaching of the Sisters of St. Dominic. In 1889, the church was committed to the spiritual direction of the Augustinian Fathers of Lawrence when the parish came under the sponsorship of the Assumption of the Blessed Virgin Mary.

The Catholic citizens of west Lawrence needed their own parish. *Catholic Church of New England* stated that, due to the "spiritual danger incurred by the children there, whose tender years prevented their attendance at Mass and Sunday-school, Rev. Father Gilmore erected a little church, at the corner of Doyle and Water Streets, for their benefit." The first mass was celebrated on Christmas Day 1878, and the church was placed under the patronage of St. Augustine. Thus, St. Augustine's Roman Catholic Church was formed.

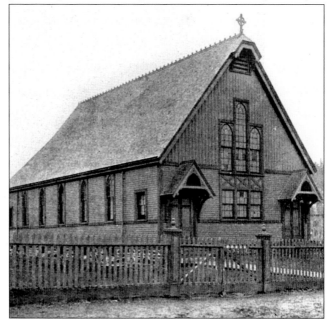

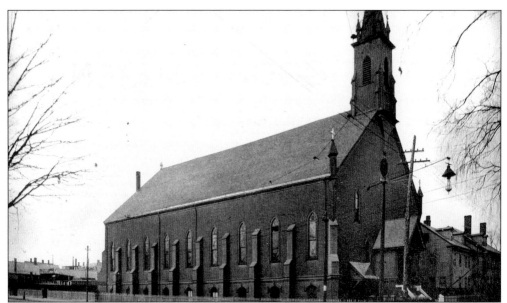

St. Laurence O'Toole's Roman Catholic Church, at the corner of Union and Essex Streets, was dedicated in 1873. The original church had no basement, but in 1884, the wood-frame building was lifted and a substantial brick basement, entirely above ground, was built. Fr. Mariano Milanese served as an assistant at St. Laurence's and started providing Italian-language services in the lower chapel. The St. Laurence parish moved to a new building at the corner of Newbury and East Haverhill Streets in 1903, and the building on Union Street became Holy Rosary.

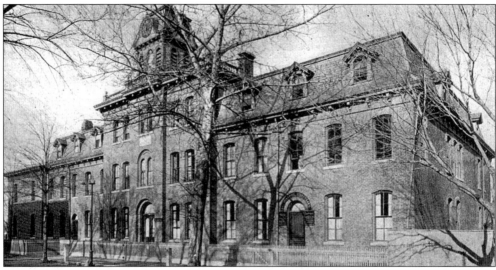

The Protectory of May Immaculate was the first institution erected in the city for purely charitable purposes. It was dedicated in 1868 and placed under the care of the Sisters of Charity (or "Gray Nuns") as an orphan asylum. The building was enlarged in 1894, and St. Joseph's dispensary was added, including the services of a physician. Between 1868 and 1895, 1,276 children were admitted to the asylum. Homes were found for 570 children, a few died, and many others were turned over to relatives. In 1895, there were 115 children in residence. The city paid for 14 of them at the rate of $6 per month. Relatives paid for 63 of the children at the rate of $3 to $7 per month. The rest of the children were dependent on the institution.

THE GOOD CITIZEN.

Published by the Young People's Society of Christian Endeavor of the Lawrence Street Congregational Church.

| Volume I. | LAWRENCE, MASS., NOV. 12, 1891. | Number 2. |

HOW TO MARK YOUR BALLOT.

Shall licenses be granted for the sale of intoxicating liquors in this city?

YES. []

NO. [X]

READ THIS BEFORE GOING TO CAUCUS.

Give us the nerve of steel,
And the arm of fearless might,
And the strength of will that is ready still
To battle for the right.
Give us the heart to feel
The sufferings of another,
And fearless power in the trying hour
To help a weaker brother.
Give us the clear, cool brain,
That is never asleep or dozing,
But, sparkling ever with bold endeavor,
Wakes the world from its prosing.
Ah! give us the nerve of steel
And the hand of fearless might,
And the heart can love and feel,
And the head that is always right.
For the foeman is now abroad,
And the earth is filled with crimes;
Let it be our prayer to God—
"Oh! give us the men for the times!"
Selected.

THE ADVANTAGES OF NO-LICENSE IN THE TRANSACTION OF THE CITY'S BUSINESS.

By Ex-Alderman Charles T. Main.

Without discussing the question of license from a moral standpoint, there is one feature which has a strong bearing upon the character and prosperity of our city. It is a side of the question which cannot be so clearly seen by others as by those who have had personal experience in the matter, although many of our citizens are beginning to have some idea of it. It is this:— The effect of the almost absolute certainty of a "Yes" vote at every election upon the composition of Board of Aldermen, and the effect which such a vote has upon the Board in their official capacity for managing the business of the of city.

A great many men shrink from assuming their share of the public work because of the amount of unselfish work that they must do, and because they oftentimes receive only the reward of sharp criticism and abuse. They are ... who are suspicious that no men ca... ...ce unselfishly

and who consequently believe that every man who accepts public office has some personal ends in view in all his actions. This ordinary condition of suspicion is intensified when a body of men have at their disposal the granting of licenses which are of great pecuniary value to those who are fortunate or unfortunate enough to procure them. Even a thoroughly honest man is liable at such a time to be accused of wrong doing. On this account, if the city continues to vote for license, the character of the Board will drop to a lower level, and it will be impossible to maintain a desirable standard.

The effect upon the Board after it has been elected is that the attention of its members is absorbed entirely by the question of liquor licenses to the exclusion of other work. I have many times heard the remark made, "After the first of May we will settle down to regular business." A man is hardly elected before the applications begin to be forced upon him, and life is made a burden from that time until the licenses are granted. This should not be, for the needs of the city must be considered. Appropriations must be made in the early part of the year, and the attention should not be diverted by any other work or annoyance.

It is evident therefore that the city does not get the best business management to which it is entitled, for the reasons given above, and briefly summarized as follows:

First. Because most men best suited to transact the city's business will not submit themselves to annoyance and possible misrepresentation.

Second. Because, after a Board is elected, it cannot get down to its most important business until one-third, and that the best third, of the year is gone.

The remedy for the above difficulty is No-License, not for one year but for a succession of years, so that it will become an established fact that the city is permanently a No-License city.

HOW LIQUOR INJURES THE IRISH.

By the Right Reverend John Ireland, *Bishop of Minnesota.*

This is an era of Irish patriotism. The virtues and the sufferings of the Irish people have awakened universal interest. The day is manifestly dawning when by the design of Providence the tears of centuries shall be dried. To hasten this deliverance many friends and patriots are on hand in numbers, each with his remedy for the ills of the Irish people. I have my remedy—Total Abstinence.

The Irish people do not drink more alcoholic liquors than others; they drink proportionally less in Ireland than the English or the Scotch do in England or Scotland. But alcohol does more harm among the Irish people than it does among others, because the warm nature of the Irish yields more readily to its flames, and in the wreck which follows they have more virtues to sacrifice. If there is a man who shou'd visit upon alcohol the whole wrath of his soul, it is he who loves sincerely the Irish people. The picture of their virtues entrances. Eight hundred years of oppression have left no mark in their freeman hearts. Selfishness vanishes beneath their soft sky. Battlefields tell of their valor as the counsels of nations speak of their wisdom. Nothing can snatch away the gem of pure morality from the coronet of the isle of virgins and martyrs. Such are the children of Erin, but in an evil hour the agents of hell distilled alcohol through their plains and over their mountains, and, despite their grand qualities, a sad ta e of misery is to be told.

A fit fuel for the flame was this Irish nature, with its fiery blood and its generous aspirations. This has been Ireland's curse, and he who still loves alcohol joins hands with Ireland's most bitter foe. "Far more than landlordism," has said one of the most zealous opponents of landlordism, Mr. A. M. Sullivan, "has intemperance impoverished Ireland." Mr. Villiers Stuart, M. P., for Waterford, has made this statement: "One-half of the amount annually spent in drink in Ireland would, if applied for the purpose, buy in fifteen years the fee-simple of all the farms in Ireland." "Never did crowbar," the Irish Bishops tell us in a synodal letter, "wreck as many homes through the land as intemperance has done." Poor Ireland has had many foes; among the most relentless, the most cruel, if we would speak the truth, we must number the whiskey dealer.

Irish exiles have been landing on the shores of America from the first days of

The temperance movement and women's suffrage immediately followed the Civil War. Gospel Temperance Mission (right) was located on Essex Street. It moved to 21 Broadway in the 1890s, changed its name to the Charles G. Adams Rescue Mission and Home, and presented daily religious services, visited the sick, provided meals and lodging, and offered a free

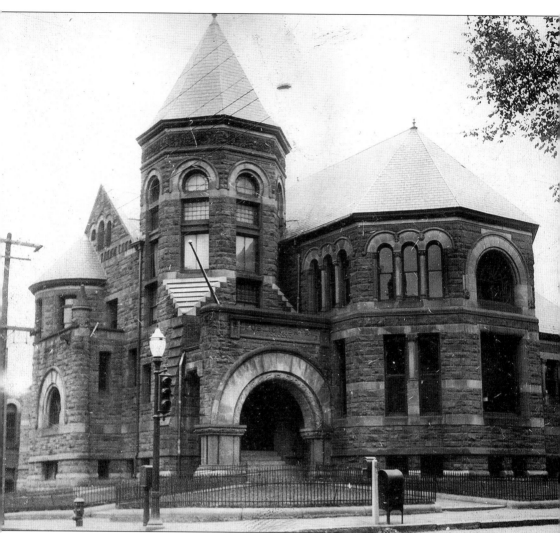

The Franklin Library Association was formed in 1847 with Capt. Charles H. Bigelow, who engineered the Great Stone Dam, functioning as its first president. Abbott Lawrence donated $1,000 to purchase books that would, according to the 1873 Report of the Board of Trustees, "tend to create mechanics, good Christians and good patriots." An additional $5,000 came to the association from Abbott Lawrence's will after he died in 1855. In 1872, the association turned over its library and funds to the city of Lawrence, and the Lawrence Free Public Library was born. The library was first housed in the Saunders Block but, due to its popularity, moved to rooms in the Odd Fellows hall on Essex Street. Its first building (seen here), designed in the Romance Revival style by George G. Adams, a local architect, was constructed on the southwest corner of Hampshire and Haverhill Streets at a cost of $50,000. It opened to the public in 1892, and by 1895, the library housed 44,235 volumes that were used by 8,424 borrowers. The White Fund presented a series of lectures at the library every year.

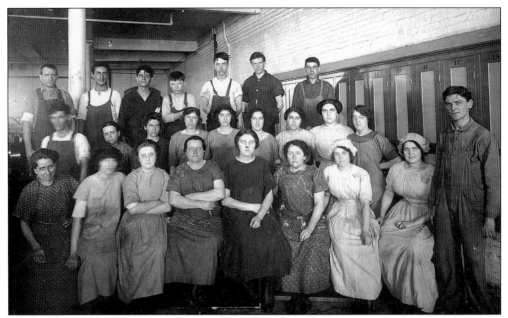

Pacific Mills provided a library for its operatives, seen here, at the cost of 1¢ per week and included history, travel, biography, poetry, science, and general literature. Periodicals and newspapers were also provided and made available in the reading rooms. In 1890, the collection of more than 5,000 books was donated to the Lawrence Public Library.

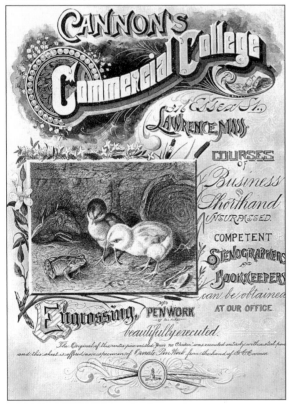

Cannon's Commercial College, located in the Central Building, began operation in 1881. With Gordon C. Cannon as principal, the college taught bookkeeping, commercial arithmetic, and business penmanship. Shorthand and typing were added later.

UNITY CLUB.

AT LIBRARY HALL ON THE EVENINGS
DESIGNATED.

Phases of
Current Thought.

OCT.-MAY, '95-96.

ALL CORDIALLY INVITED.

Many literary and cultural groups sponsored lectures and social events. The Unity Club, associated with the Unitarian church, hosted lectures on various topics. It met weekly in the Unitarian church during the latter part of the 19th century, read papers written by local historians, and invited guests to speak from all over the country. In 1872, several gentlemen met at the house of Dr. George W. Garland to form a social and literary club called the Lawrence Monday Night Club. These men included clergymen, headmasters, librarians, mill agents, and other professionals. The membership was limited to 25. The club also hosted excursions with Monday Night Clubs from other cities to various salubrious locations for an afternoon recreation (often including the ladies). The Fortnightly Club was a women's group that sponsored a program of lectures from October through June.

The Lawrence Society of Natural History and Archaeology was founded in 1866. For a period of time, the society rented a room in the Central Building, where it displayed a collection of artifacts and offered its members a variety of lectures, outings, and other activities. The society was part of the New England Federation of Natural History Societies, whose regional meeting was held in Lawrence on September 29 and 30, 1911. At that time, the Lawrence chapter had 90 members from Lawrence and the surrounding towns. Over the years, the society held joint activities with the Andover Society and the Beekeepers Association. In 1927, due to the decrease in membership, the society relinquished its room and distributed its bird specimens to the Lawrence Public Library (seen to the left). The remaining items were taken over by the Lawrence Boys' Club.

Natural History Society Excursion.

The members of this Society, their friends, and citizens desiring, can visit Salem, Mass., on Friday, June 24th, 1887. The members will spend a portion of the day at the Museums and rooms of the Peabody Academy of Science and Essex Institute. Train leaves Boston and Lowell Station, Essex St., at 7. 45 A. M., return at 4.40 P. M. Fare for the round trip 75 cents (no half fares) Tickets may be had at depot ticket office, at A. R. Sanborn's law office, 239 Essex St., or at Greer's Drug Store, 259 Essex St. Those who wish can take Horse Cars in Salem for the Willows (fare 5 cents each way), or for Marblehead (fare 7 cents each way). Members generally will make it a basket picnic.

Per Order,

J. P. LANGSHAW, Secretary.

Old Residents' Annual Supper,

——AT CITY HALL,——

WEDNESDAY, EVENING, FEB. 5th, 1879.

(UNLESS DATE IS CHANGED BY AGREEMENT.)

Free Tickets to Members and Guests specially invited; none others admitted.

It is hoped this will be truly a simple and wholesome old-folks gathering, where all will be socially equal, and the plain dish of the poor will be received with the same thankfulness as the lavish provision of the rich, where all members and invited guests will be made welcome. Our numbers are now so large that few outside of the Association can be invited.

The tables will be supplied with such viands as your means will allow, and your generosity prompt you to voluntarily furnish. If all members do something towards supplying food, the interest will be more general.

Cooked meats and poultry of all kinds, baked beans, brown and white bread, *rolls* and cake, pies and fruit of all kinds will be acceptable, and milk, butter, sauces and preserves will not come amiss.

Bring your package of substantials or niceties to City Hall, on the afternoon of the day, (Wednesday, Feb. 5th,) before 5 o'clock P. M. You will find some one in waiting at any time after 12 o'clock to receive it and return your basket.

COMMITTEE OF LADIES

To solicit supplies in the Wards and take charge of the supper at the hall :

MRS. SUSAN H. DANA, *Chairman.*

Ward 1—Mrs. Abel Webster, Mrs. Mary E. Currier, Mrs. J. F. Merriam.

Ward 2—Mrs. Caroline E. Marshall, Mrs. Mary G. Dow, Mrs. H. B. Robie.

Ward 3—Mrs. Jos. Shattuck, Mrs. Abel G. Pearson, Mrs. Mary Manders.

Ward 4—Mrs. E. R. Hayden, Mrs. E. P. Poor, Mrs. J. Clinton White.

Ward 5—Mrs. Fred Butler, Mrs. E. W. Burbank, Mrs. Amos Carter.

Ward 6—Mrs. James M. Wood, Mrs. Albert D. Swan.

Committee on Tea and Coffee.—Mr. Charles Smith, Mrs. Albert Blood.

Committee on Tables, Seats and Furniture.—Messrs. Withington, Bunker and Sweeney.

Committee to procure Crockery and Table Cutlery.—John D. Glidden and Mrs. A. M. Fay.

Committee to receive Guests, act as Ushers and care for Clothing.—Messrs. Ordway, Rollins, Lamb, Fuller and Edwards, Mrs. Mary Morrison Mrs. Hezekiah Plummer and Mrs. Geo. Littlefield.

Committee on Tickets, Invitations and Doorkeepers.—Messrs. Wright and Hayden, and Mrs. A. M. Fay.

Committee to arrange for Short Exercises after Supper.—Messrs. Tarbox, Robinson and L. Stoddard, and Misses O'Keefe and Wetherbee.

Mr. W. R. Pedrick will purchase such supplies as are not furnished.

Galleries and ante-rooms at City Hall open at 6 1-2 o'clock. Supper served in Hall at 7 1-2 o'clock. Close at an early hour. *Only members and invited guests admitted by ticket.*

NO NEW MEMBERS RECEIVED FROM FEB. 1st TILL AFTER THE SUPPER.

The Old Residents' Association of Lawrence was organized in 1877 "to collect and preserve facts relating to the history of Lawrence; to encourage social intercourse, local enterprise, and intellectual and moral culture." Anyone of good character who had lived in the city or in its vicinity for 25 years could become a member with proof of citizenship and a $1 fee. The meetings regularly drew several hundred attendees, who listened to lectures on local history given by the members, sang "old-time" songs, and socialized over refreshments. Within a few years, the group began holding concerts with professional musicians at the large halls in the city and annual suppers.

The Essex County Philatelist.

Vol. I.　　　　　LAWRENCE, MASS., SEPT., 1889.　　　　　No. 1.

The Real Inventor of the Postage Stamp.

Look over the history of inventions and you will find that the majority of inventors were poor men, unable to practically apply what their inventive genius had set forth in theory, or represented by illustrative models, experiments, etc. Capitalists, shrewd speculators, have invariably gobbled up the ideas and propositions of thinkers and inventors. Real talent goes unrewarded, while unworthy persons happening to be in the possession of capital enriches himself at the expense of the poor talented worker.

A politician, who for forty years lived upon the merits of another man, whom he succeeded in suppressing systematically, has been finally exposed, but not until it was too late. His monument has been erected, and it stands forth in the city of London as an example of the rottenness and fraudulency of our capitalistic age.

The recent issue of an "Encyclopaedia Britiannica" says, in regard to the introduction of cheap postage in Great Britain: "For all practical purposes the history of postage stamps begins in Great Britain, and with the great reform of its postal system in 1839-1840." After giving instances in which the impressed stamp had been in use, or had been suggested for postal purposes in this country and elsewhere, the article proceeds: "Finally, and in its results most important of all, the 'adhesive stamp' was made, experimental, in his printing office at Dundee, by Mr. James Chalmers, in August, 1834. These experimental stamps were printed from ordinary type, and made adhesive by a wash of gum. Their inventor had already won local distinction in matters of postal reform by his strenuous and successful efforts, made as early as in the year 1822, for the acceleration of the Scottish mails from London. These efforts resulted in a saving of forty-eight hours on the double journey, and were highly appreciated in Scotland. There is evidence that from 1822 onwards his attention was much directed towards postal questions, and that he held correspondence with the postal reformers of his day, both in and out of Parliament.

L. P. M.

(*To be continued.*)

Illegible Postmarks.

There is no valid reason why the postmark on a letter should not be as legible as the business card that is often printed on the corner of the envelope. It is frequently important to know when and where an envelope containing a letter or manuscript was mailed, and the postmark must be depended on to give the information. In most cases the dependence is vain. Careless clerks put only a blur where the postmark ought to be, and the public suffers, sometimes seriously in consequence. Yankee ingenuity can certainly devise a canceling machine which will cancel stamps and postmark letters rapidly and well. Probably there is such a machine already invented.

The public should protect itself by insisting that the post-office regulations requiring legible postmarks showing when

The middle class spent time and money on a variety of interests, illustrated by the career of William M. Stuart, born in Lawrence in 1873. After graduating from Phillips Andover Academy, he lived with his family on Jackson Street in Lawrence and worked for the *Lawrence Telegram*. In 1904, he ran as a candidate for state representative for the 7th Essex District. While living in Lawrence, he developed a lifelong interest in stamp collecting. He edited and printed a small newsletter called the *Essex County Philatelist* for a few years.

Six

BROTHERS AND SISTERS

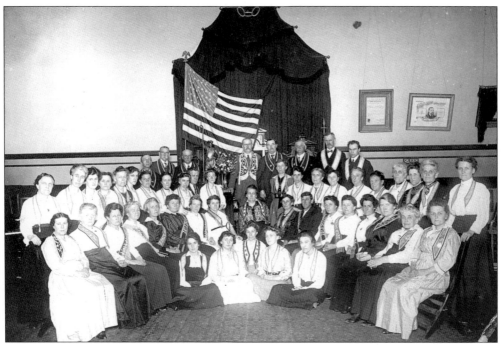

No city of similar size had more social or fraternal organizations than Lawrence. By the turn of the century, the city was host to at least 300 such organizations that offered residents a rich and varied life away from their toil in the mills. A number of these groups owned property and ran programs from their own buildings. Often there were auxiliary women's groups attached to organizations specifically for men. For example, the Rebekah Lodge, associated with the Independent Order of Odd Fellows, had two chapters, Ruth and Crystal, in Lawrence. Both met in the Odd Fellows hall. This view shows one of these lodges that shared the principles of faithfulness, hospitality, purity, and dedication, as portrayed by women characters of the Bible.

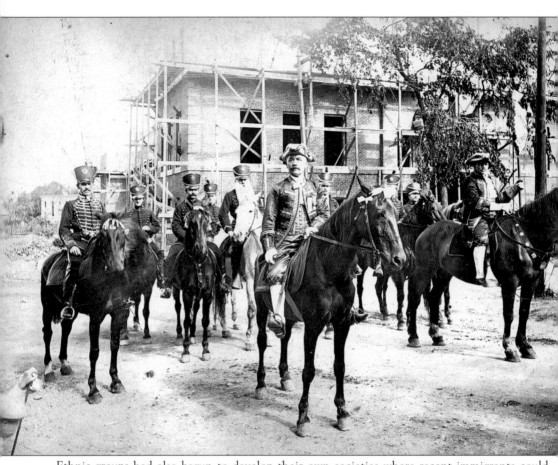

Ethnic groups had also begun to develop their own societies where recent immigrants could socialize with their own countrymen. The Irish had the Lawrence Irish Benevolent Society and two chapters of the Ancient Order of Hibernians. The Scots rallied to the Order of Scottish Clans, the Clan McPherson, and the Caledonian Club. The Germans socialized in the German Cooperative Association, the German Aid Society, Turners' Sisters Society, and Natural Heil Kunde. The French had the Society L'Union St. Joseph, La Societe St. Jean Baptiste, and Le Club Canadien Francais. The Order of Orangemen had two chapters in Lawrence. This photograph shows the German Day parade. (Courtesy the Lawrence History Center.)

During the Civil War, the Grand Army of the Republic was the name of the Union army. On December 10, 1867, the first Grand Army of the Republic post in Lawrence was formed to service veterans who returned to civilian life. This post (named after Sumner Henry Needham) met for many years at Needham Hall, at 180 Essex Street, on Wednesday evenings. Its activities included fairs and entertainments used for fundraising to aid veterans and their families, upkeep of grave sites, and social events such as the local, state, and national encampments.

Originally from Methuen, Grecian Lodge of Ancient Free and Accepted Masons was rechartered in Lawrence in 1847. Their first meeting was held at a building at the corner of Essex and Amesbury Streets. In 1872, Grecian and all other Masonic bodies moved to the Saunders Block. Other lodges chartered in Lawrence were Tuscan (1853), Phoenician (1870), Mount Sinai (1861), and Lawrence Council (1868), as well as the appendant bodies of the Bethany Commandery and Knights Templars (1864). This photograph shows one of the halls in the Saunders Block.

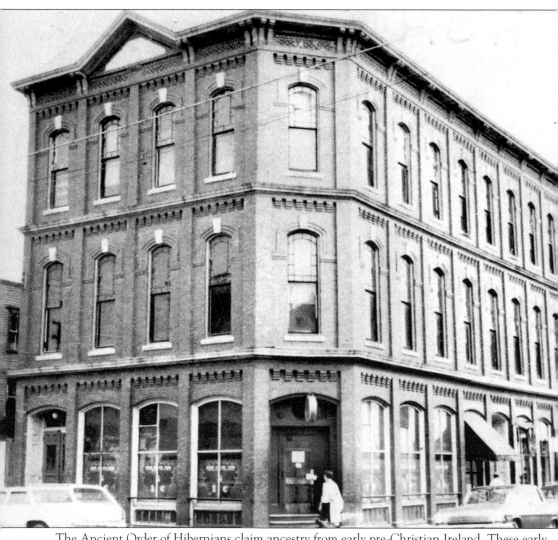

The Ancient Order of Hibernians claim ancestry from early pre-Christian Ireland. These early military orders required of their members good moral character, perfect physical health, and uncorrupted lineage. Members must also be able to pass a severe test of body and mind. The modern rebirth of the order is said to have started with Rory Oge O'Moore in 1565 in order to protect Catholics from the injustices of the penal code. In 1836, the first Ancient Order of Hibernians was founded in New York City, and one was founded in Boston in 1857. No exact date can be given for the founding of the Lawrence lodge, but it appears to have been sometime in the late 1860s. The publication the *Emerald* lists the date as 1872. A ladies auxiliary was organized in May 1904. The ladies auxiliary's motto is "friendship, unity, and true Christian charity," with the purpose of aiding young Irish immigrant girls. Hibernian Hall was erected on the corner of White and Oak Streets in 1887. (Courtesy the Lawrence History Center.)

Lawrence Lodge No. 65 of the Benevolent and Protective Order of Elks was founded in 1887 in the old Odd Fellows hall on Essex Street. This came only 19 years after the first lodge was organized in New York City by a small group of men affiliated with the theatrical profession. The intent of this organization was to advance the principles of Americanism together with charity, justice, brotherly love, and fidelity. The Lawrence lodge was the third such group in Massachusetts (after Boston and Springfield) and, at that time, initiated 46 charter members. The early meetings were held in the Knights of Pythias hall (later known as Needham Hall). Lawrence Day was a featured event allowing Lawrence Lodge to escort their fellow Elks through the great mills. Lawrence Lodge has aided the Greater Lawrence area with many charitable accomplishments.

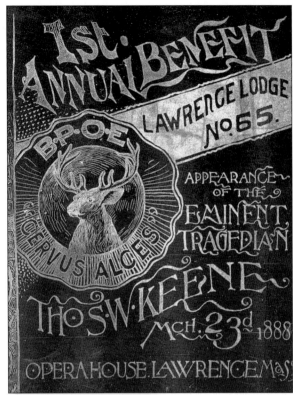

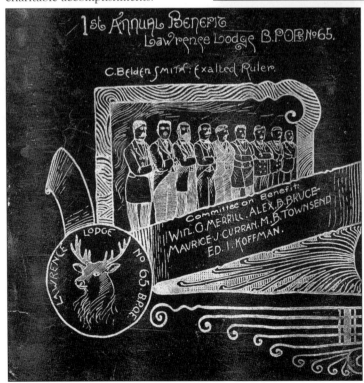

The first fraternal organization in Lawrence was the United Brothers Lodge of the Independent Order of Odd Fellows, instituted in 1847 in the building on the southeast corner of Hampshire and Common Streets. Later, the brethren moved to larger quarters on the north side of Essex Street midway between Lawrence and Pemberton Streets. In 1874, the lodge ultimately moved to their own building (left), located on the south side of Essex Street.

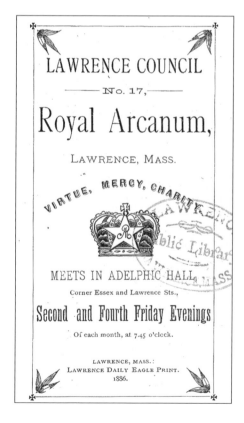

Royal Arcanum was a mutual beneficiary association to unite fraternally "white men of sound body, health and good moral character, who are socially acceptable, and between twenty-one and fifty-five years of age." Royal Arcanum took on the role of social safety net. It aided the widows and orphans of deceased members and established a fund for the relief of their members. Each member had to undergo an exhaustive medical exam with research into his family history to detect hereditary tendency to disease. Royal Arcanum had two chapters in Lawrence (Lawrence Council No. 17 and the Merrimack Council No. 1148).

Seven
LEISURE TIME

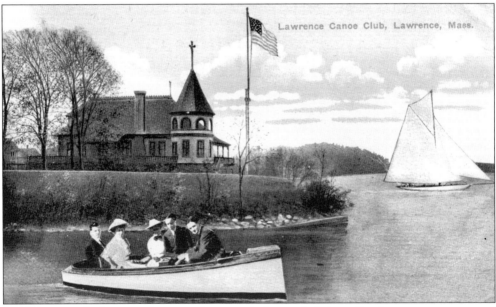

Lawrence Canoe Club, Lawrence, Mass.

City streets with the new electric railways and electric lighting offered a constant source of entertainment. Professional sports teams were being started in American cities. The city took great advantage of the river, not only to run the mills and fill the reservoirs but also to give its citizens a means of affordable recreation. The Merrimack River was lined on both sides above the dam with bathhouses and boating clubs. The Lawrence Canoe Club had become a gathering place for the elite of the city to watch and participate in water sports and to socialize in the group's beautiful boathouse.

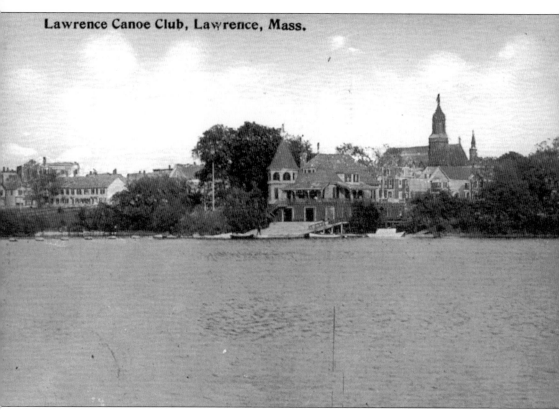

Lawrence Canoe Club, Lawrence, Mass.

In 1885, a group of young men started the Lawrence Canoe Club "to encourage canoeing, to promote physical culture, and foster a unity of feeling among those interested in canoeing, rowing, bowling and tennis." The group rented, remodeled, and repaired a boathouse and erected a large piazza on the front of the building facing the river. The second floor was a clubroom and parlor while the first floor was used to store boats and canoes owned by the club and its members. Later, when a movement grew to establish boating at Phillips Academy and other places, two large racing shells were procured from Yale for the use of the academy at the boathouse. In 1889, the Canoe Club experienced a boom in membership from residents of Lawrence, Methuen, and Andover, and the club decided to limit the membership to 250 men with a waiting list of 50 or so applicants.

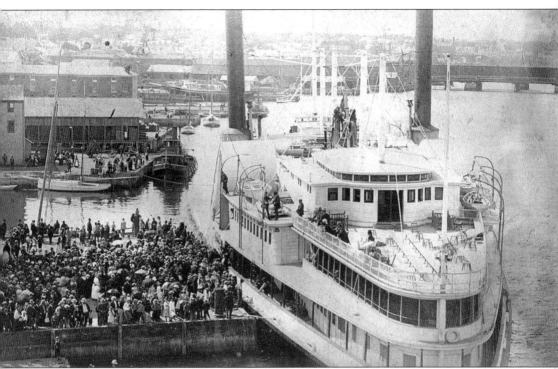

Very early, people in authority talked about using the Merrimack as an inland waterway from Newburyport at the mouth of the Merrimack all the way up to Lawrence. They still dreamed of dredging the river to make this possible well into the 20th century. Occasional steamers made it up the river to Lawrence when the water was high, but the dream was never to become a reality. Instead, excursions down the Merrimack were another form of recreation before the electric railways, with groups of partygoers taking the train to Haverhill and transferring to a steamer to cruise the river down to Salisbury Beach or Plum Island. This picture shows the *Empire State* in Newburyport on August 27, 1886.

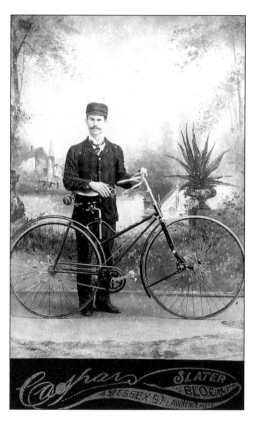

A half-mile course was set up in South Lawrence for the Lawrence Riding Park, which was used for horse races as well as bicycle races. The Lawrence Bicycle Club met regularly, and, according to the *Lawrence Evening Tribune*, members would rhapsodize about "a noiseless glide o'er the pleasant paths of earth, in silent communion with the beauties of nature." (Courtesy the Lawrence History Center.)

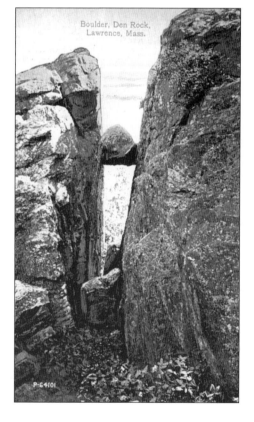

The city's park commission was formed in 1890. Parks in Lawrence included the common, Storrow, West, and Union Parks, as well as a few playgrounds. Seen here is Den Rock (80 acres). It and some land along the Spicket River had just been acquired. The original intent was to make Den Rock into a cemetery, but those plans were never acted upon. Instead, the area remained a bit of wild woods near the city, close enough for Sunday excursions.

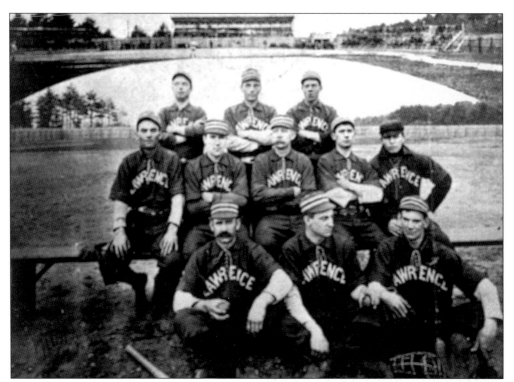

Lawrence has always had a passion for baseball. Veterans returning from the Civil War probably brought the game to the city since the first recorded game took place shortly thereafter. The city fielded teams that competed in the New England League during the later decades of the 19th century.

Cricket was a popular pastime in the 19th century. At one time, Lawrence fielded two teams: the Lawrencers and the Merrimackers. They played teams from Everett, Boston, Lowell, Somerville, and Andover. (Courtesy the Lawrence History Center.)

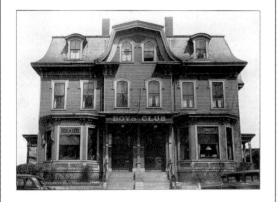

Fifty - third Annual Report

1891 ✧ 1944

Lawrence Boys' Club

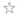

$12,000.00

Twelve Months Budget Campaign ✧ May 4 to May 18

The Lawrence Boys' Club had its start in 1891 at 224 Broadway. Its goal was to provide a suitable building for the boys of Lawrence to spend their evening hours "in a safe, pleasant, profitable manner with surroundings calculated to improve them in mind, body and morals." The club, open to youths of any nationality and religious belief, fostered its goals through the use of written materials, athletics, and entertainment. In 1896, the club moved to larger quarters at 325 Methuen Street, seen here.

People would often make their own entertainment. Evenings spent listening to the family prodigy play the piano or joining a sing-along was common evening fun. Amateur theatricals also enlivened long winter evenings. This image, from a stereo slide, shows members and friends of the Jennings family dressed to entertain. (Courtesy the Jennings collection.)

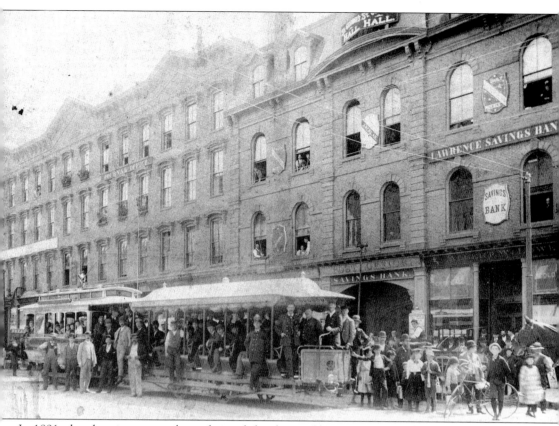

In 1891, the electric street railway changed the shape of leisure time in New England. At the end of the century, a passenger could pick up the trolley in Lowell and cruise past Varnum's Landing, Grand View, Glen Forest, Lawrence, and Haverhill. After Haverhill, one's destination was the Pines in Groveland or the sea by way of Merrimack, Salisbury Beach (Lawrence's Saratoga), Black Rocks, or Newburyport. According to the *Journal of Fine Art*, "There is not another electric road in New England to equal the Lowell, Lawrence, and Haverhill Street Railway Company for elegance or conveniences nor rate of charges while the comfort and safety of the passengers is at all times their chief consideration."

Glen Forest, like other leisure-time destinations, was the creation of the electric railway company, which transported families and church and fraternal groups to the area. Glen Forest (its original name was Barker's Grove) was a pretty site sloping down to the Merrimack River consisting of 43 acres of pine, oak, and maple trees in Methuen. The park opened to the public in 1895. The pavilion was divided into a dance hall and a dining room, and a piazza lay directly next to the boat dock. A bandstand and ball park were also provided for the holiday crowd. In the early years of the 20th century, a theater was added. Glen Forest's season ran from May through October. The postcard to the left shows the entrance to Glen Forest. The image below is from the cover of a small travel brochure for the electric railway.

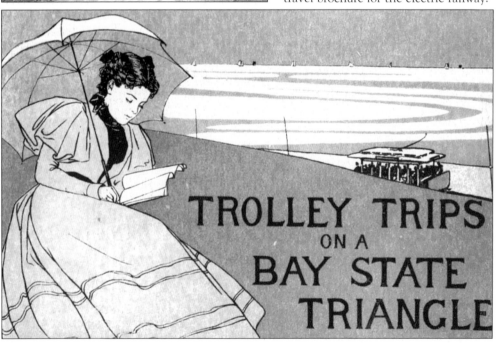

TROLLEY TRIPS ON A BAY STATE TRIANGLE

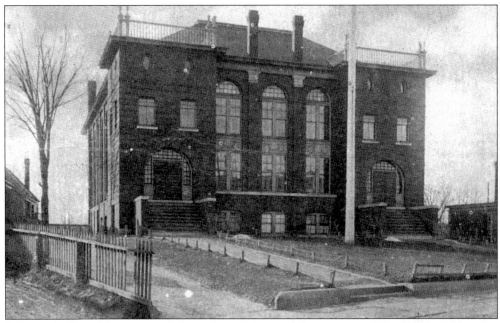

Lawrence's Turn Verein was dedicated to the sport of gymnastics. The Turner motto was "A sound mind in a sound body." In 1853, a number of followers began to practice a variety of gymnastics at a house on Union Street. A band composed of three guitars, one accordion, and one fife enlivened the dedication of the gym, which contained a high bar and parallel bars. Over the years, Turn Verein had quarters at the corner of Jackson and Common Streets, then on the third floor of a house on Essex Street, and finally in the building above, Turn Hall (at 44 Park Street), dedicated in 1896. By 1900, the membership had reached 500. The photograph below shows a performance on the stage of the auditorium. (Courtesy the Lawrence History Center.)

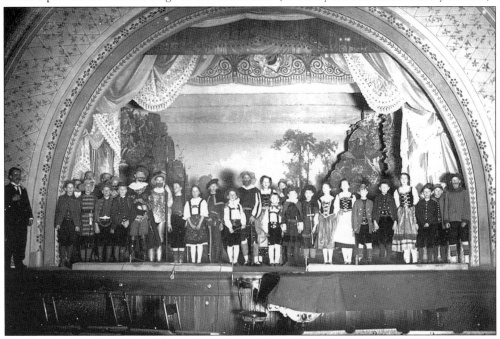

A variety of entertainers and public events appeared on the stage platform of city hall over many decades. A number of local churches used the hall as a place of worship until their own building could be constructed. Civil War volunteers drilled here, and Sumner Needham's flag-draped coffin lay in state here. There were also balls, political rallies, and religious revivals. The hall served as a morgue during the Pemberton Mills disaster and was the site of memorial services for Presidents Taylor, Lincoln, and Garfield.

84

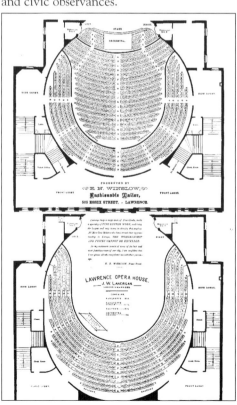

The opera house was considered to be the most ornamental building in the city. Its interior was finished in hardwood and crimson plush, like a railroad car. The seating included two balconies and four box seats above the lower-floor parquet. The opera house hosted a variety of entertainments from the day it opened, including musicals, dramatic presentations, and civic observances.

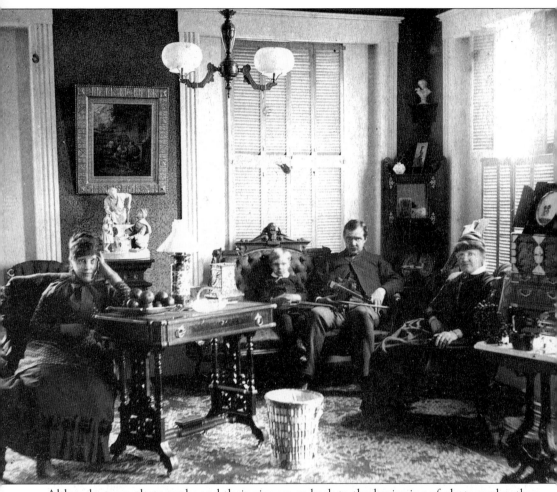

Although stereo photographs and their viewers go back to the beginning of photography, they did not become a fixture in the American home until the Civil War, after Oliver Wendell Holmes (the elder) developed a light, inexpensive hand viewer in 1862. Stereo slides allowed people to bring the three-dimensional world into their parlors. A series of slides distributed to members of Congress in 1871 showed Yellowstone Park, our first national park. Popular sites all over the world were represented, and slides of significant events and disasters chronicled world events much as television does today. Rarely, stereo photographs showed individuals, private dwellings, and pets. This stereo slide shows Fred Fifield's parlor in the 1880s. He married into the Jennings family. Documents from the Jennings collection relay that, "They were good citizens and faithful workers in the mills and other industries of Lawrence. Their descendants are now widely scattered." (Courtesy the Jennings collection.)

Musical entertainment was readily available from a variety of musical groups. There were singing societies like Leiderkranz, Vorwaertz, Lyra, Arion, and Glocke. The Chadwick Club and the Comus Club endeavored to bring professional orchestras to the opera house and city hall. The Chadwick Club was named after George Whitefield Chadwick, a noted composer who spent his childhood in Lawrence. The club presented professional musical performances for the public from 1894 into the 1940s. The Columbian Orchestra, a local orchestra, played the first concert sponsored by the club. The Pacific Mills Band was composed of Pacific Mills employees. Frank A. Murphy of the company's employment department organized the band, and Walter Hall was its conductor.

SECOND CHAMBER CONCERT,

UNDER THE AUSPICES OF THE

Chadwick Club, • • Pilgrim Hall, Lawrence,

TUESDAY, FEBRUARY 19, AT 8 P. M.

The Adamowski Quartet.

Mr. T. ADAMOWSKI, 1st Violin Mr. MAX ZACH, Viola
Mr. A. MOLDAUER, 2d Violin Mr. J. ADAMOWSKI, Violoncello

ASSISTED BY

MR. JOHN C. MANNING, Pianist.

. . Programme . .

1. *Beethoven* QUARTET IN A MAJOR, OP. 18, No. 5

 Adagio.
 Menuetto.
 Andante con variazione.
 Finale.

2. *Chopin* SCHERZO IN B FLAT MINOR

 MR. MANNING.

3. *Tschaikowsky* ANDANTE FROM QUARTET

4. (a) *Paderewski* MELODIE
 (b) *Zerzycki* . MAZURKA

 MR. ADAMOWSKI.

5. *Cæsar Cui* QUARTET IN C MINOR

THE PIANOFORTE USED IS A MASON AND HAMLIN.

Third Concert, Kneisel Quartet, Tuesday, March 19.

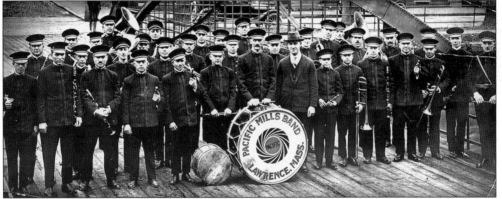

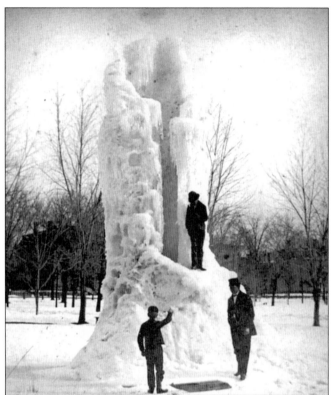

There are a few archived images of lighthearted recreation in Lawrence from the early years of photography. The water fountain on the common would regularly freeze, and over and over again someone took a picture of it. This is one such cabinet card. It took a bit more effort to capture such a moment with the type of photography they had then. The photographer may have thought that he was observing something extraordinary. The common was the city's first playground, and a blanket of snow was a great reason for heading to the park.

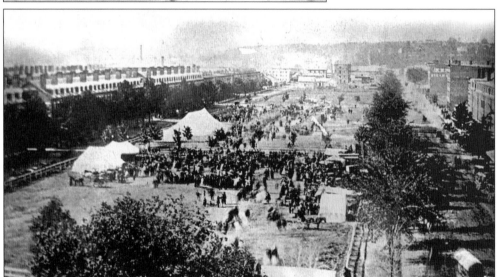

The Essex Company retained ownership of undeveloped land between the south side of Essex Street and Methuen Street, from Franklin to Amesbury Streets, for most of the 19th century. The area was called "the Corporation Reserve" and was a place for recreation and big events just like the area on south Union Street where the circus and Essex County fair regularly camped. The site gradually diminished in size as commercial Essex Street (running nearly a mile from Union Street to the other side of Broadway) became further developed. This photograph can only have been from the 1870s.

Eight

A WALKING TOUR

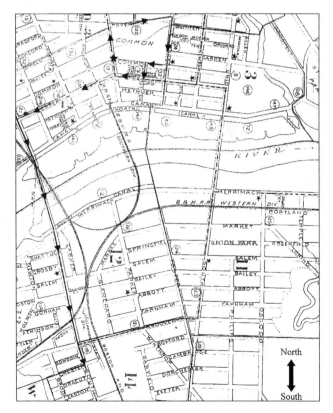

The only way to get a feeling for the city landscape during the heady years of Lawrence's Gilded Age is to walk the streets as they were in that period. If we could take ourselves back to the cobblestone streets of Lawrence in 1895, we would recognize a few things. The basic shapes and names of the streets are the same. The 17¹/₂-acre common is already here, but lush overhanging elm trees frame the paths and walkways. The tour begins at the star on the southwest corner of the common. Follow the arrows.

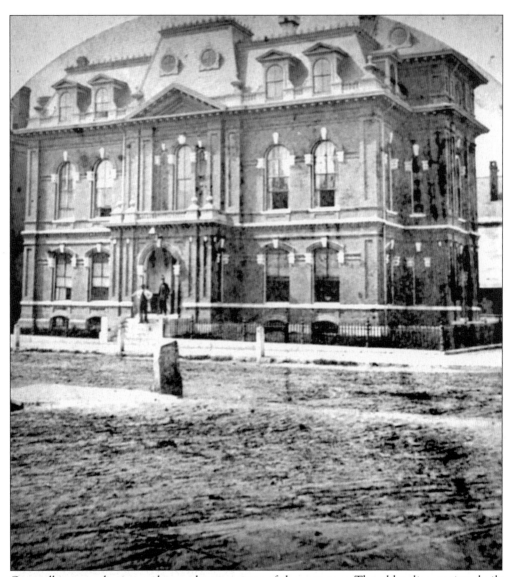

Our walking tour begins at the southwest corner of the common. The old police station, built in 1867, is diagonally across from the corner. At the first town meeting (1847), 10 constables were appointed to preserve law and order, and the first lockup was located at the corner of Broadway and Common Street. In 1850, police headquarters were in town hall, and the jail cells were nestled in the arches supporting the vaults of the town clerk's office, prompting complaints by citizens of unsanitary conditions. When Lawrence became a city in 1853, a police force replaced the constabulary. This was followed in 1867 by the construction of the brick building seen in this image. In 1895, the police force was composed of 47 permanent policemen, and there were 32 signal boxes throughout the city.

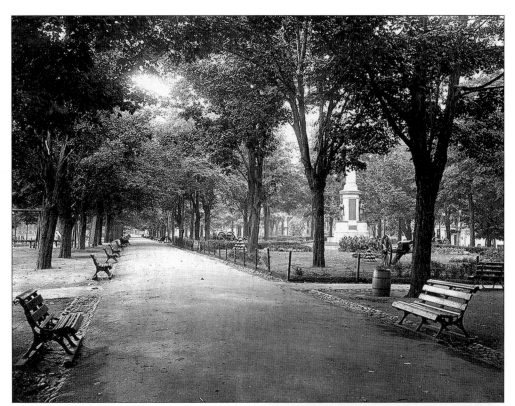

Looking northeast (above) into the common, one can see iron railings and regularly interspersed park benches leading up to the Soldier and Sailor's Monument. The monument was erected in 1881 by Needham Post No. 39 of the Grand Army of the Republic and dedicated on November 2 amidst a display of fireworks and calcium lights. With the help of a committee of citizens, money had been collected from several corporations, the Grand Army of the Republic, schoolchildren, the Ladies Choral Union, and donations by individuals and businesses to cover the monument's cost of $11,111. On its crown is a figure representing "Union" designed by David Richard and cut from Quincy granite. At the base are three figures in bronze: an infantryman, a sailor, and a dismounted cavalry officer. The cavalry officer was modeled after Capt. Micah Ryder Brown, a Lawrence native and West Point graduate. Three bronze tablets list the local servicemen killed during the Civil War. The image to the right shows the Lawrence Street Congregational Church in the distance.

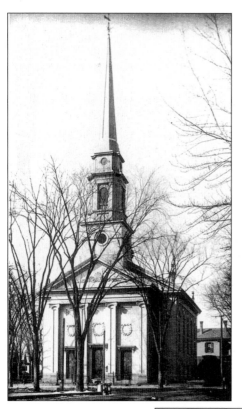

There is a water pump and trough for horses on the south side of the common as you walk up Lawrence Street. Trolleys regularly follow tracks north and south on Lawrence Street. On the northwest corner of the common at the intersection of Lawrence and Haverhill Streets is the spire of a graceful church. The Merrimack Congregationalist Society was organized on August 1, 1846, and changed its name to Lawrence Street Congregational Church the following year. This building was dedicated on October 11, 1848.

Haverhill Street is a broad and elegant boulevard. Looking west from the common, one can see both the First Baptist Church and the spire of St. Mary's Catholic Church. The First Methodist Episcopal Church is off in the distance where the street makes a turn to the left. In this very old stereo slide, trees line both sides of the street, and some of them are boxed at their bases to protect them from horses.

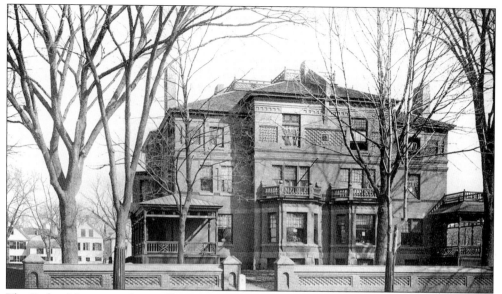

The Parker Manor was diagonally across from the Lawrence Street Church. This elegant brick residence was owned by Pacific Mills. Managers employed at the mill lived here.

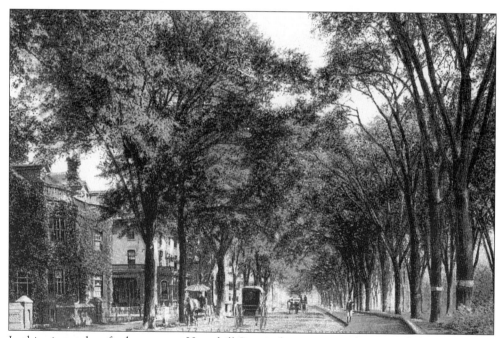

In this view, taken farther east on Haverhill Street, there are more homes and churches. Trees line both sides of the street. The area bounding the common was a place to walk on a Sunday afternoon after church services.

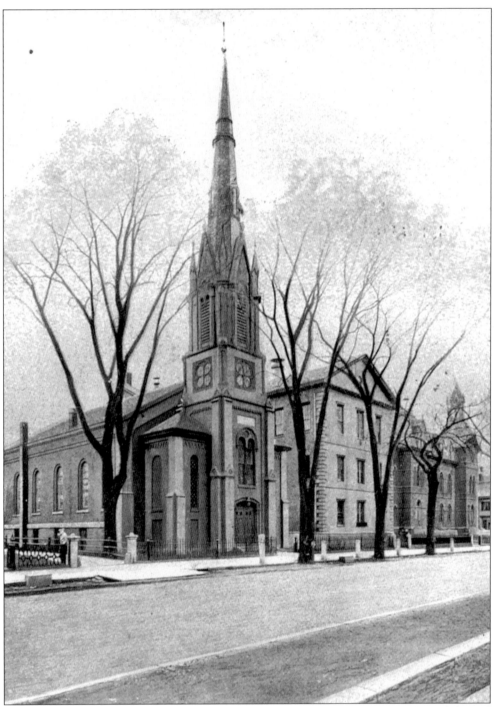

About halfway down the block was the Church of the Good Shepherd (Universalist), dedicated in 1853. The Universalist congregation was founded in 1847. The city's newly created Manual Training School was located to the rear of the church, facing Oak Street. Young men could complete their academic studies in the morning at the high school and devote themselves to shop and drawing in the afternoon at the school.

94

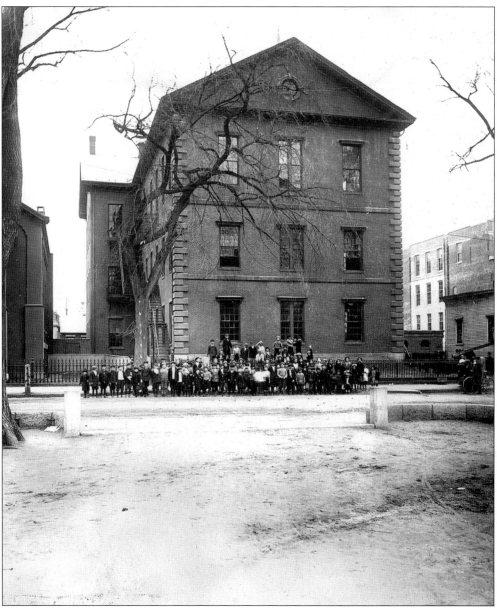

The Oliver Grammar School is next-door to the Manual Training School. The original edifice, called the Haverhill Street School in 1847, was for students between the ages of four and eight years. By 1848, it was already called the Oliver Grammar School, named for Henry K. Oliver, a one-time mayor of the city. Two years later, the Oliver Middle and Primary School was built in the lot to the back of the school.

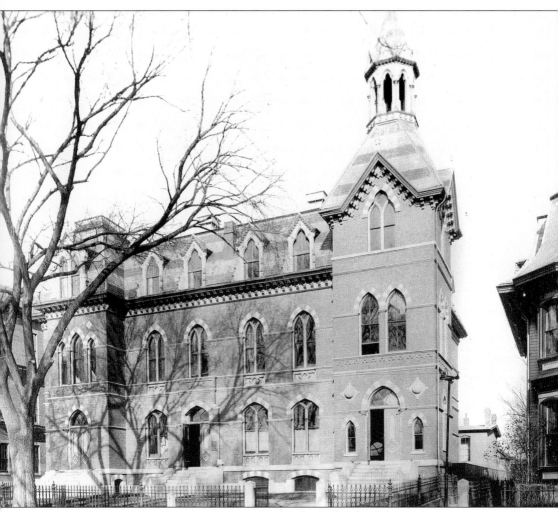

Directly east of the Oliver Grammar School is the high school, built in 1867. In 1847, the first 17 students were taught on the first floor of the Oliver Grammar School. In the picture, showing the three entrances at the front of the building, the easterly one is for boys, the westerly one for girls. In 1892, this building graduated Robert Frost and Elinor White, his future wife. There was a normal school at the rear of the high school, where graduates of the high school were taught to be teachers.

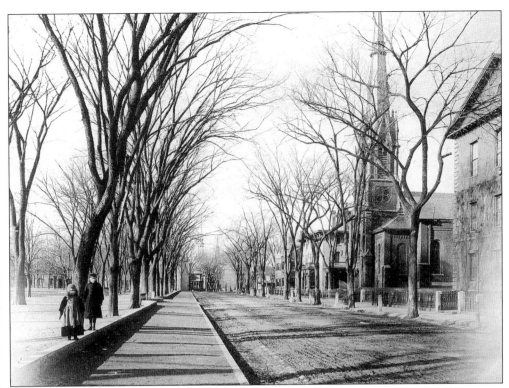

Looking back, we see an elegant and well-groomed Haverhill Street. To the east of the high school, Trinity Congregational Church (formerly the Central Congregational Church) met for the first time on Christmas Day 1849 and held its services at city hall until August 1854. Its first home was a brick building at the corner of Essex and Appleton Streets. On August 12, 1859, this structure was destroyed by fire, and the congregation returned to meeting at city hall. The church fathers then began work on the building shown here. They first met in the basement of the new building in January 1860, and the new church was dedicated on June 28, 1883.

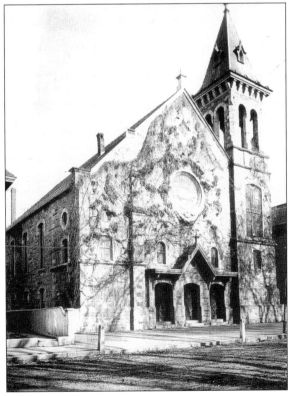

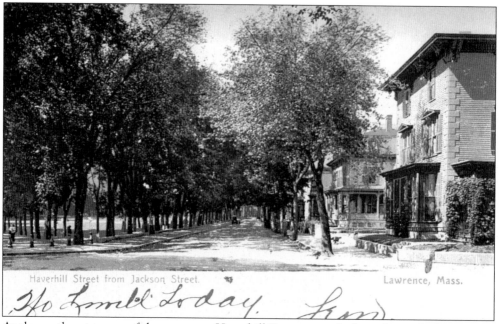

Haverhill Street from Jackson Street. Lawrence, Mass.

Ho Lunel' Loday.

At the northeast corner of the common, Haverhill Street meets Jackson Street. Jackson Street is a lovely residential area near churches, commercial Essex Street, and this wonderful park. Looking north from the common, we see one beautiful home after another on both sides of the street. As the city grew, the middle class moved away from the mills, and many of these spacious and elegant homes were subdivided into tenements.

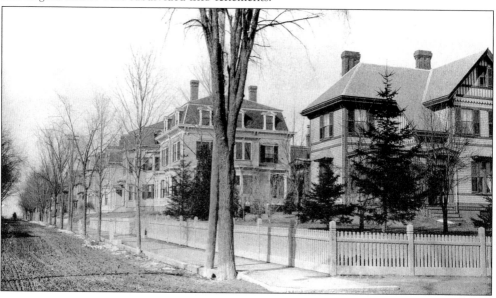

The Unitarian church sits across from the northeast corner of the common. The First Unitarian Society was organized in 1847 by a warrant issued by Charles S. Storrow. The society met in the Odd Fellows hall until its first building was erected in 1850. In order to fund the church, pews were rented to the congregation at a charge of $80 each. In 1859, the church was damaged by fire. The building shown here was the church built that same year.

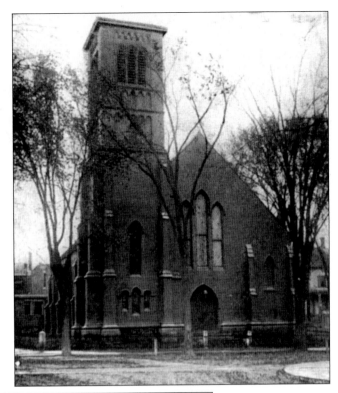

As we turn right and follow the common, Jackson Terrace appears on our left.

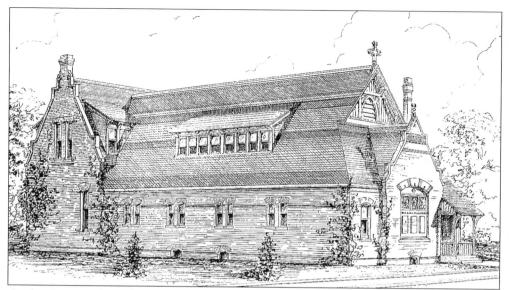

Garden Street is the next side street east of the common. The new Grace Chapel was just a few steps up the block on the left-hand side. The original, wooden Grace Church building had been moved to this site in 1852. It was used as a vestry until 1878, when it was torn down to make way for the new elegant brick chapel illustrated here.

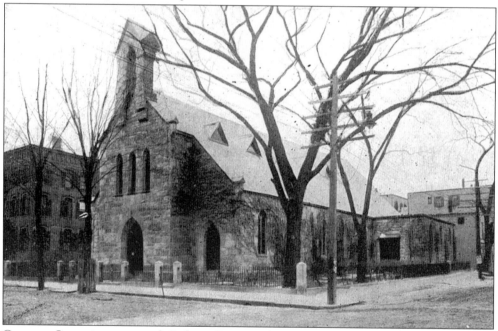

Common Street intersects with Jackson Street at the southeast corner of the common. Grace Church, an enduring image of early Lawrence, sits just opposite the common. When the Great Stone Dam was under construction, the Missionary Association of the eastern district (Essex and Middlesex Counties) of the Massachusetts Episcopal Church wanted a church to service the men working on the dam. The church was established on land granted by the Essex Company. The original building was wooden, and the first services were held on October 11, 1846. The church in the picture replaced the wooden structure in 1852.

This view of the common looks northwest from the corner at Jackson and Common Streets. The common was a gift of the Essex Company to the town of Lawrence. A committee of five—Sam W. Stevens, Ivan Stevens, Abiel Stevens Jr., M. D. Ross, and A. D. Blanchard—was formed to confer with the Essex Company about the conditions under which the latter would deed the land. Much of the area was a large sand heap; other parts were sown with buckwheat or cabbage; and the area along Jackson Street was an alder swamp with a brook running through it.

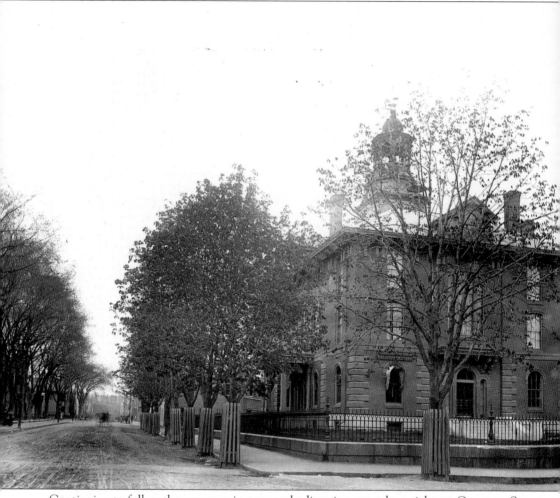

Continuing to follow the common in a westerly direction, we take a right on Common Street and pass the courthouse and city hall. In the early years, citizens of Lawrence had to travel to Salem or Newburyport when dealing with matters that entailed the superior court. After the Lawrence Town Hall was built, quarters were provided there for what was then called the court of common pleas. A county courthouse was built in 1858 with land provided by the Essex Company. A foundation was provided by the city, and the building was erected by the county. The courthouse was destroyed by fire a year later and rebuilt in 1860 as the building seen in this 1895 photograph. Plans were formed at that time to do a major renovation on the building in 1900.

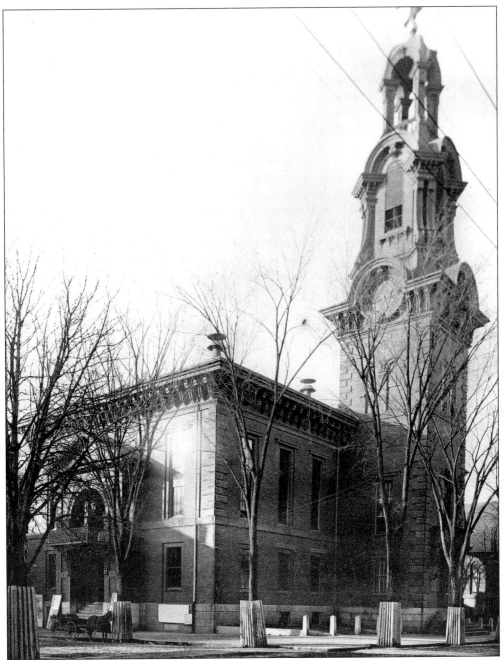

Town business was conducted first in Merrimack Hall and later in the Freewill Baptist Meeting House. City hall was built in 1849, when it was called the town house (it received its present name when the city was incorporated in 1853). Eli Cook, William I. Stetson, and Alexander Mair of Boston obtained the contract to build the hall from plans created by Melvin and Young. The eagle perched on top of the building is over nine feet long and appears to be preparing for flight, because, according to Maurice Dorgan's *Lawrence Yesterday and Today*, the new town of Lawrence, "so full of promise, might ever be actuated with the noble inspiration to spread and bear learning, virtue, and wisdom to all parts of the world."

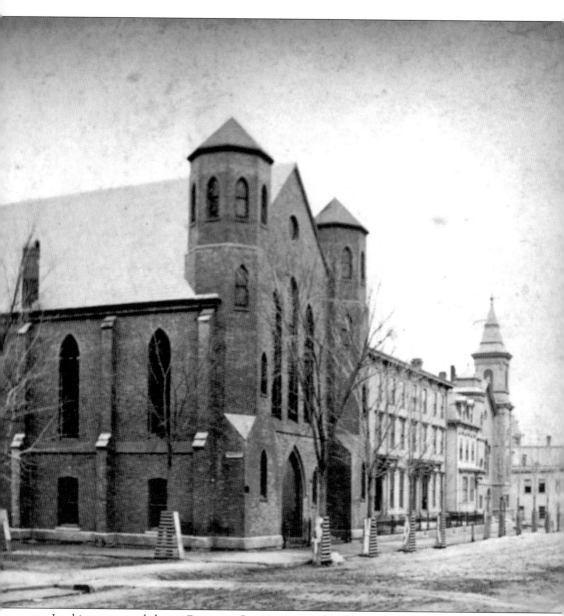

Looking westward down Common Street, we see the First Freewill Baptist Church and the Second Baptist Church. Sixty-seven members of the First Baptist Church met in 1860 to organize a new congregation. The church met for 15 months in city hall and later acquired land at the corner of Lawrence and Common Streets from the Essex Company. The meetinghouse (with its steeple on the far right) in this stereo slide was built in 1874. The church was active in proselytizing the many new immigrants of Lawrence. The First Freewill Baptist Church was an advocate of the Freewill Baptist movement, which believed in "free will, free communion, and free salvation." The First Freewill Baptist Church was organized in 1847 in a boardinghouse on Turnpike Street. The first building was a small chapel at the corner of Haverhill and White Streets, and the first person baptized was Josiah H. Stokes in the Merrimack River that same year. The congregation later used the pond in the common for baptisms. The building in this view was dedicated in 1857 at the corner of Common and Pemberton Streets.

We now make a left turn at Appleton Street between the courthouse and city hall. The Post Office Block (St. George's Hall), where Young Men's Catholic Lyceum, Sons of St. George's, and Northern Mutual Relief Association each meet, appears on the southeast corner of Essex and Appleton Streets. Essex Street is the longest and busiest thoroughfare in the county.

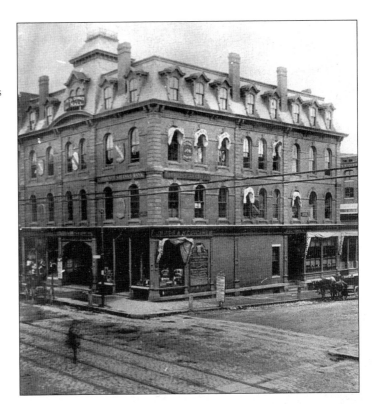

Farther east down Essex Street we see Sweeney's Block and the Hotel Brunswick. Needham Hall is across Essex Street. The Order of Security, the Ancient Order of Foresters, Needham Post No. 39 of the Grand Army of the Republic, and the Sons of Veterans met in this hall named after the Civil War martyr Sumner Needham. The *Lawrence Sentinel*, one of the city's newspapers, had its office here.

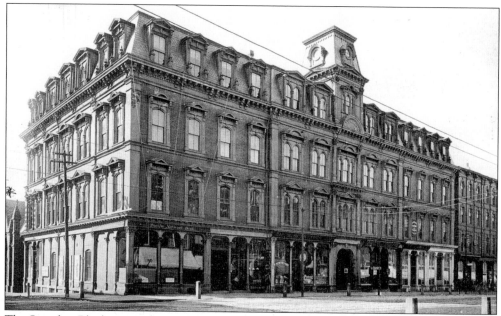

The Saunders Block covers the south side of Essex Street from Appleton Street to the beginning of Pemberton Street. It housed the Free Masonry lodges, the Alma Club, Manchester Unity, the Lawrence Board of Trade, and New England Telephone and Telegraph offices. Also on the same side of the street are Prince Hall, which housed Black Prince Lodge (a Knights of Pythias), the Order of the Scottish Clans, New England Order of Protection, and the offices of architect George Adams, who designed and built the new public library building. The Adams Building (also designed by George Adams), located next-door, was occupied by the Kiley Brothers store.

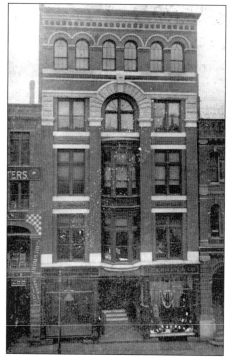

Pilgrim Hall (also called Phil Sheridan Hall, Columbian Hall, and Lincoln Hall) is the next building with offices for the Order of the Mayflower, Christian Scientist Church, the United Order of Pilgrims Fathers, the United Order of the Golden Cross, and the Ancient Order of United Workmen.

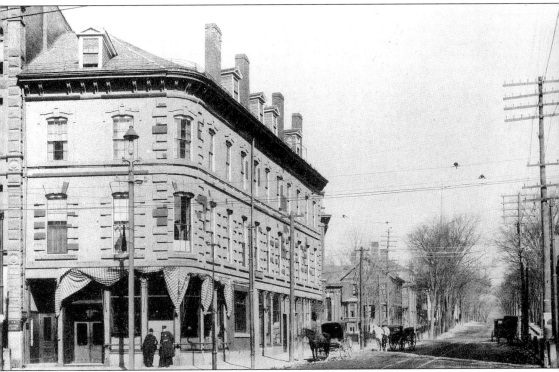

Walking west, along the two blocks leading up to Lawrence Street and the remaining blocks leading to Broadway, we see the center of commerce and entertainment, as well as the lifeblood of the city. The many stately buildings leased space to civic, fraternal, and religious groups. The sidewalks were often filled with people running errands, spending an evening out, or just going about their lives. Seen here, at the northwest corner of Lawrence and Essex Streets, is Adelphic Hall.

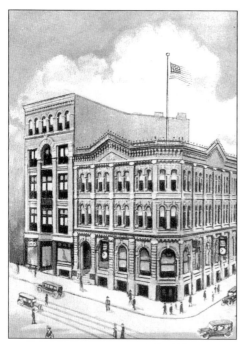

Charles Storrow was the president of the Essex Savings Bank when it was incorporated in 1847. It was first located on the second floor of the Bay State Building, at the northeast corner of Lawrence and Essex Streets. In 1875, the bank bought the land directly across Essex Street and built the handsome brick building seen here.

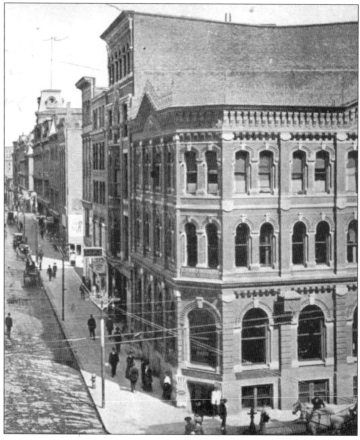

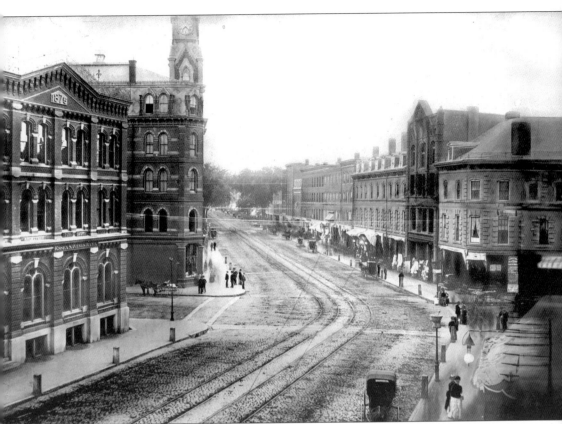

Lawrence's first large building (with the tower) stood at the southeast corner of Essex and Lawrence Streets. The Odd Fellows hall was built principally as a meeting place for this well-established fraternal group, which occupied the top two floors. The public library leased the second floor until 1891. The L. C. Moore Bargain Emporium, the largest department store in Lawrence, occupied the ground level of the building at that time. Adelphic Hall (also known as Prohibition Hall and White Rose Hall) stood directly across on the north side of Essex Street, and many groups—including the Knights of Columbus, Order of United Friends, Knights of Honor, Massachusetts Catholic Order of Foresters, Sons of Temperance, Lodge of Good Exemplars, Young Men's Prohibition Club, Morning Star Lodge, and the Elks—held their meetings here. The Stearns Building was just next-door.

Still walking west along Essex Street, we see on the south side of the street the Central Building (left) and the opera house (below), the latter opened to the public in 1881. The building also contained a train station in the lower level, run by the Boston and Lowell Railroad Company. The facade of the opera house is described as Romanesque or arched finish, and the construction materials are pressed brick, hammered granite, and galvanized iron. The height of the building is 72 feet, the same size as the Odd Fellows hall on the same block.

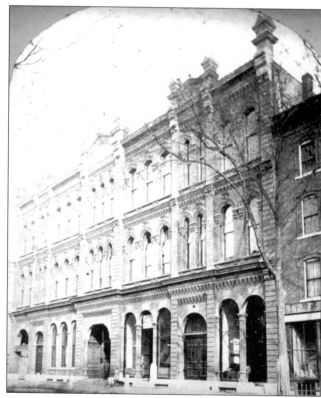

The Red Men's hall, home of the Home Circle, Order of United American Mechanics, and the Order of Orangemen, was on this block. Separated from Red Men's hall by taverns and shops was the Central House, a commercial men's hotel. The Gleason Building (far right) stood a bit farther west on Essex Street. At the corner is the building that houses Pedrick and Closson Real Estate.

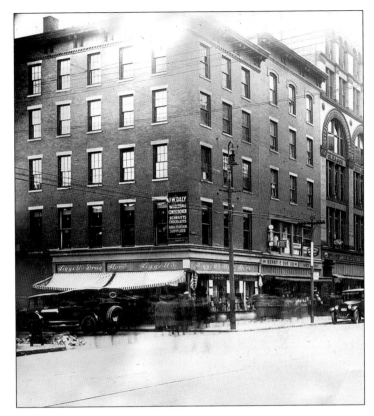

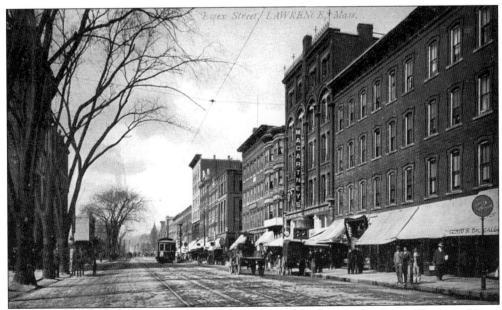

In this view looking west from Amesbury Street, we can see the bay windows of the Essex House Hotel on the north side of the street.

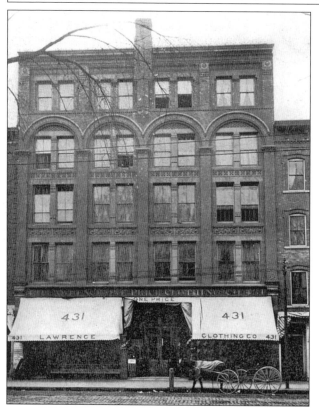

After crossing Amesbury Street, we come to a variety of small businesses, including the Dismal Failure Lunchroom and the Modern Shoeshine shop, on the south side of Essex Street. The Dismal Failure placed numerous advertisements in newspapers and other publications extolling "everything neat, tasty and in season" and was open 24 hours a day. There were also some significant structures like Forbes Block, the Fairfield Building (left), Marston Block, and the Essex House hotel on the north side of Essex Street.

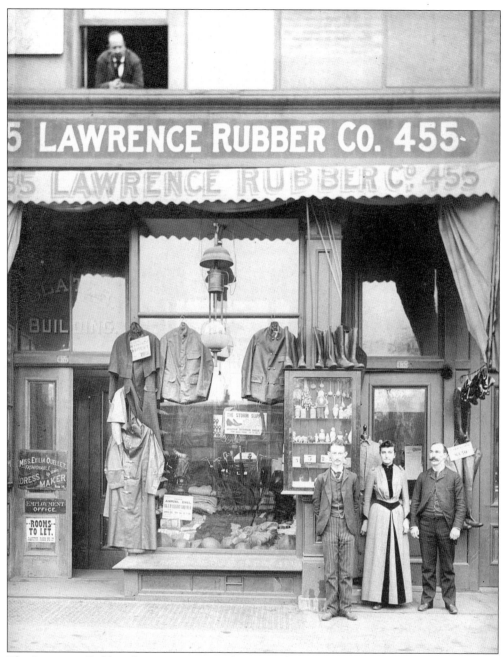

The Lawrence Rubber Company, just to the west of Hampshire Street, was a wholesale and retail establishment owned by Isaac Crocker. Its products included hose, belting, packing, syringes, sheeting, oil clothing, ladies' mackintoshes, and rubber boots. (Courtesy Joe Bella.)

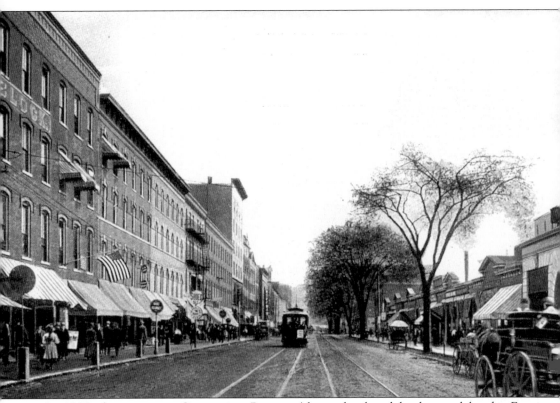

In 1895, the remaining Corporation Reserve (the undeveloped land owned by the Essex Company) was on the south side, between Hampshire and Franklin Streets. On the north side of Essex Street in this view are the Lamprey Block, Howard's Block, and the Ordway Block, along with the Bicknell Brothers clothing store with their elaborate clock.

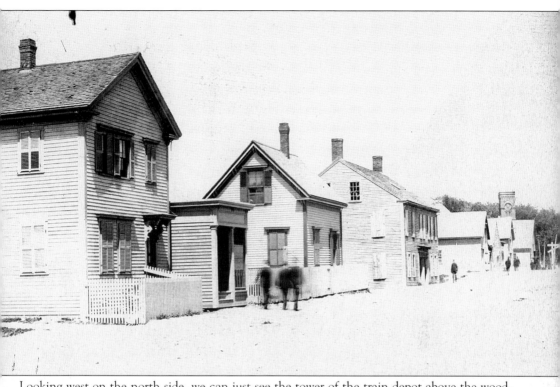

Looking west on the north side, we can just see the tower of the train depot above the wood-frame buildings.

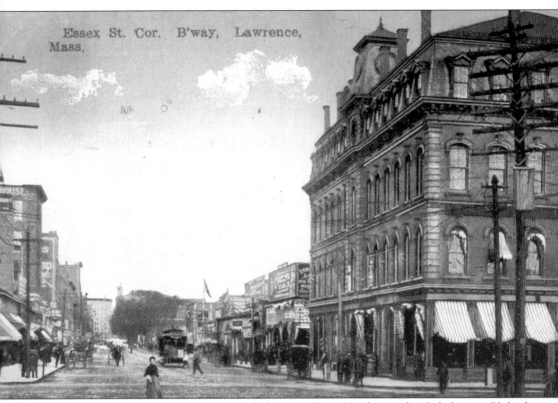

Essex St. Cor. B'way, Lawrence, Mass.

We come to the imposing Brechin Block, housing Treat Hardware, the Caledonian Club, the Anchor of Hope (temperance), Broadway Savings Bank, Lawrence National Bank, and Whitney Real Estate (at the corner of Broadway and the south side of Essex). Just before Broadway on the north side of Essex Street is a station of the new electric railway.

Broadway was another of the wide avenues lined with houses of commerce. It was originally an extension of the Medford-Andover Turnpike, one of several turnpikes and canals that began to radiate out of Boston at the beginning of the 19th century. When Lawrence was built, the road was first called Turnpike Street, but the name was changed to Broadway in 1868. (Courtesy Joe Bella.)

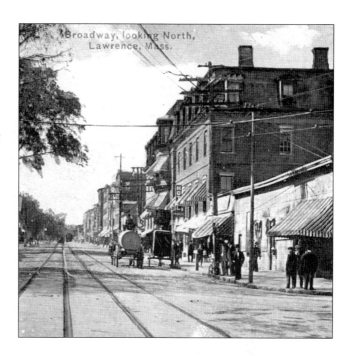

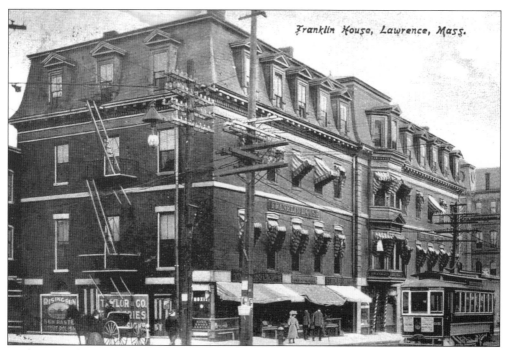

Looking north on Broadway, we see the Franklin Hotel. Originally called the Coburn House after the proprietor T. J. Coburn, it was Lawrence's first hostelry. (Courtesy Joe Bella.)

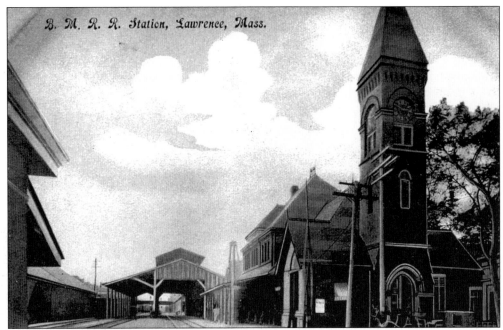

Looking directly across Broadway to the west, we see a small park that leads directly over to the North Lawrence depot of the Boston and Maine Railroad, the most heavily used of three train stations in Lawrence at this time. It was opened for business on March 16, 1879.

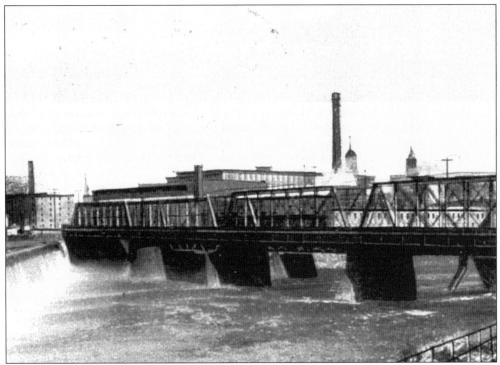

Turning left (south) on Broadway, we cross Canal Street and the North Canal by the Broadway Bridge.

118

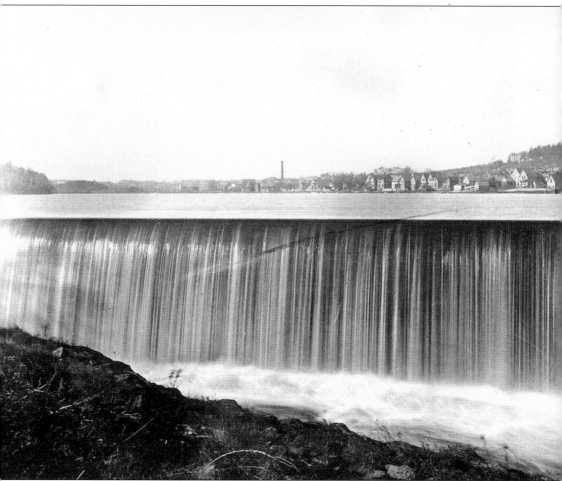

Looking west from the Broadway Bridge, we see the Great Stone Dam powering the great mills on either side of the Merrimack River. The engineering firm Gilmore and Carpenter contracted the dam construction in 1845 shortly after the Essex Company was formed. The chief engineer was Charles H. Bigelow. Constructed with granite blocks laid with hydraulic cement, the dam is over 900 feet wide and 35 feet thick at its base. At a cost of $250,000, it was the most massive dam of its kind in the country. Continuing south over the Broadway Bridge, we enter South Lawrence, more of a village than part of a city. Across South Canal and Merrimack Street are the trappings of industry: railroad lines, the beginnings of new factories, and the south terminus for the railroad.

The fire department's Engine House No. 3, built in 1869, is on the right-hand (west) side at Crosby Street. The Lawrence Fire Department has 7 fire stations and 29 permanent firemen. Absence of serious fires has lowered fire insurance rates in Lawrence below those of any city in Massachusetts.

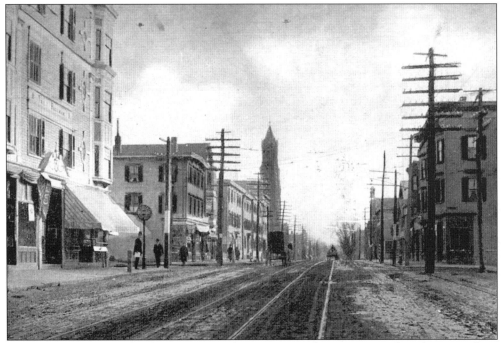

South Broadway was the first commercial area in South Lawrence. The electric railway extended its way south into Andover in the late 1890s. There was still a lot of open land to be developed.

The tallest buildings on south Broadway are Daley's Block and St. Patrick's Church. St. Patrick's was formed in 1868, and a wooden building was dedicated on March 17, 1870, in honor of the patron saint. The present brick building, designed by P. W. Ford in a modern geometric Gothic style of culled red brick and trimmed with Longmeadow sandstone, was dedicated on June 17, 1894. In its basement is located the chapel. St. Michael's Church in North Andover is a mission church of St. Patrick's.

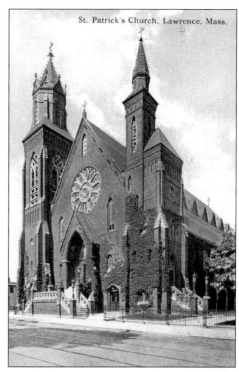

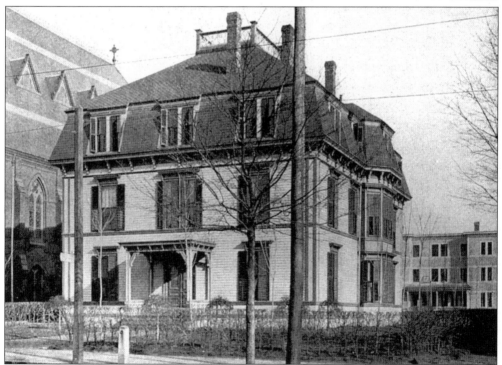

St. Patrick's rectory, just south of St. Patrick's Church, is a three-story wood-frame building with a mansard roof built by Fr. Michael T. McManus. Father McManus, like so many other citizens of Lawrence, was born in Ireland and came to America as a child.

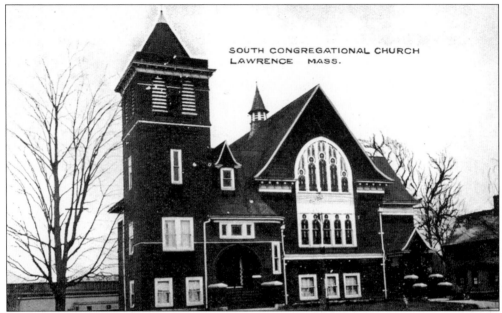

South Congregational Church, only a short distance from St. Patrick's and on the same side of the street, started as a Sunday school in a house on Andover Street in 1852. The congregation moved to the passenger room of the Boston and Maine station in 1857 and to a small chapel in 1859, which was enlarged in 1861. A new church, shown here, was built in 1869.

The Saunders School is the only other significant structure on South Broadway. The school, on the west side of Broadway, was built on land owned by the Saunders family, and the Daniel Saunders house was one of the structures already in existence before the town's incorporation. Daniel Saunders Sr. was one of founders of Lawrence, and his sons, Daniel Jr. and Caleb, were early mayors of the city (the 6th and 18th, respectively).

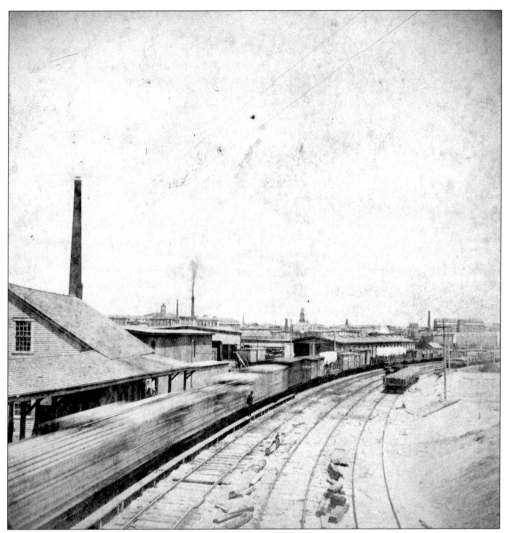

As we continue south, the entrance to the South Lawrence Train Station appears just off Broadway to the east. This depot of the Boston and Maine Railroad was one of the city's earliest stations. It was joined by stations off north Broadway and in the first floor of the opera house. This tour takes us to what was a largely undeveloped area in 1895. As we continue down Broadway, businesses and houses give way to open fields and stands of trees. The road continues proceeding south to Andover.

BIBLIOGRAPHY

American 1890s: a Cultural Reader. Durham, North Carolina: Duke University Press, 2000.

Atlas of the City of Lawrence, Mass., 1896.

Brands, H. W. *The Reckless Decade: America in the 1890s*. New York: St. Martin's Press, 1995.

Buckham, John Wright. "Henry K. Oliver: the Composer of Federal Street." *New England* vol. 15 no. 4, February 1897, pp. 384–399.

Dorgan, Maurice. *History of Lawrence, Massachusetts with War Records*. Cambridge, 1924.

Dorgan, Maurice. *Lawrence Yesterday and Today*.

Fifty Years a City 1853–1903: A Souvenir of the Semi-centennial Anniversary of Lawrence, Massachusetts. Lawrence, Massachusetts: Hildreth and Rogers, 1903.

Graphic, Historical, and Pictorial Account of the Catholic Church of New England Archdiocese of Boston. Boston: Illustrated Publishing Company, 1895.

Lawrence city directories, 1871–1900.

Lawrence Gazetteer. Lawrence, Massachusetts: Merrill, 1894.

Lawrence Public Library. *Report of the Board of Trustees*, 1873.

Lawrence up to Date 1845–1895. Lawrence, Massachusetts: Rushforth and Donoghue, 1895.

Lawrence, William. *Memories of a Happy Life*. Boston: Houghton Mifflin, 1926.

Semi-centennial History of Lawrence, Massachusetts. Lawrence, Massachusetts: Keough, 1903.

Trachtenberg, Alan. *The Incorporation of America: Culture and Society in the Gilded Age*. New York: Hill and Wang, 1982.

Note: Information and photographs from the following sources, located at the Lawrence Public Library, were also used: the Forrest C. Hinckley photograph collection, the Jennings family photograph collection, the Pacific Mills collection, and the streetscapes photograph collection.

TIMELINE

	LAWRENCE	UNITED STATES
1870	Lawrence population, 28,921; Augustinian Society organized.	Tweed ring broken; Robert E. Lee dies.
1871	Timothy Deacey elected captain of Company I, 6th Regiment.	Chicago fire; Barnum opens first Greatest Show in Brooklyn.
1872	Saunders Hall dedicated.	Susan B. Anthony arrested while trying to vote; 776 buildings burn in Boston.
1873	Ground broken for Tower Hill reservoir.	Economic depression; *The Gilded Age* published.
1874	Col. Richard O'Sullivan Burke of Fenian Army addresses mass meeting at city hall.	Massachusetts enacts first effective 10-hour day for women workers; first football game in Boston.
1875	Lawrence population, 34, 016; Orange riot.	Molly Maguires strike.
1876	Extension of horse-drawn railroad to South Lawrence.	Alexander Graham Bell invents telephone; Custer's last stand; centennial exhibition in Philadelphia.
1877	Strike of the engineers and firemen of the Boston and Maine; Alexander Graham Bell gives public exhibition of the telephone at city hall.	Great Railroad Strike; Edison invents phonograph.
1878	Steamers *Kitty Boynton* and *Charles L. Mather* come up the river with barges in tow.	First bicycles manufactured in United States; first exhibition of electric trams.
1879	New train station opens on Essex Street.	Edison invents incandescent lights.
1880	Lawrence population, 39,151; Charles Parnell visits Lawrence and receives ovations at city hall.	Street lighting installed in areas of New York City.
1881	Opera house opened.	Pres. James Garfield assassinated.
1882	Invalids' Home and Day Nursery opened; General strike of Central Pacific Mill; Broadway Bridge completed.	Chinese Exclusion Act.
1883	First Old Residents' Course presented at city hall.	Buffalo Bill organizes Wild West Show.
1884	Wrestling match at opera house between Decker and McMahon ends in a draw.	Overhand pitch and new rules for baseball.

1885	Lawrence population, 38,862; Parker Street Methodist Episcopal Church dedicated.	Fingerprints new tool of U.S. police.
1886	New city hospital building dedicated; Lawrence Electric Lighting Company organized.	Haymarket riots; AFL founded; Statue of Liberty erected.
1887	Strike of ring spinners, Pemberton Mills; Elks Lodge No. 65 organized; meeting of the mayors of Massachusetts in Lawrence.	Hawaii cedes Pearl Harbor to United States.
1888	Lawrence Board of Trade organized; strike of the weavers of the Arlington Mills.	First football league founded; first electric streetcar, Richmond, Virginia.
1889	First vote against prohibition; Canoe Club building dedicated; Lowell Street closed due to diphtheria; Pres. Benjamin Harrison entertains at South Lawrence railroad station.	Jane Addams opens Hull House; first Oklahoma land run.
1890	Lawrence population 44,654; city employees' workday limited to nine hours; destructive cyclone in South Lawrence.	Closing of frontier; massacre at Wounded Knee.
1891	First trip on the electric railway; Pilgrim's Fathers Hall dedicated.	Basketball invented in Springfield, Massachusetts.
1892	New public library opened.	Homestead Strike; Ellis Island opened; first iron and steel workers strike.
1893	New armory building dedicated.	Economic depression.
1894	St. Patrick's Church dedicated.	Pullman Strike.
1895	Lawrence population, 52,164; city celebrates 50th anniversary of the building of the dam; Glen Forest opened.	Cuban revolt; Vanderbilt's mansion, the Breakers, completed in Newport, Rhode Island.
1896	Bavarian Hall built.	Tootsie Rolls and Cracker Jacks introduced; Boston begins building subway.
1897	Wetherbee School built.	First Boston Marathon.
1898	Company F of the 9th Regiment and Company I of the 8th Regiment sent to serve in the Spanish-American War.	Spanish-American War; United States gains Guam, the Philippines, and Puerto Rico; annexation of Hawaii.
1899	Cornerstone laid for new high school.	Boston removes last horsecar; Coca Cola first bottled; 144 miles of roads hard-surfaced; 13,824 cars on the road.
1900	Lawrence population, 62,559; German Presbyterian Church built.	About 30,000 trolleys on some 15,000 miles of track; average age of death, 47; U.S. population, 76 million.

INDEX